The Bergdorf Goodman Cookbook

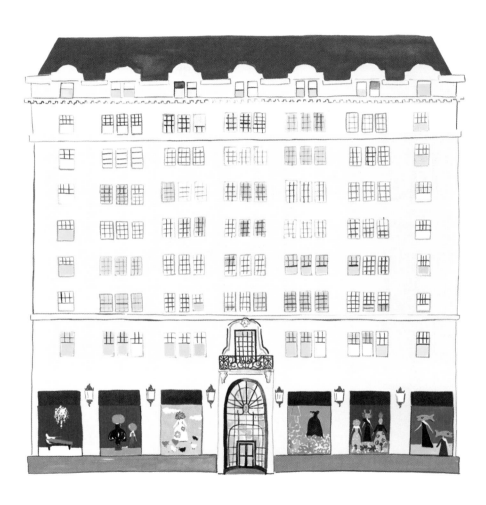

The Bergdorf Goodman Cookbook

Laura Silverman

FOREWORD BY
Hal Rubenstein

ILLUSTRATIONS BY
Konstantin Kakanias

HARPER
DESIGN
An Imprint of HarperCollinsPublishers

Contents

Foreword

"**N**o one who's really into fashion ever eats anything!"

I've lost count as to how many times I've heard this declaration during the twenty-five years I've been surrounded by beautiful clothes. Constant repetition has elevated it almost to the level of mantra, so one could hardly be blamed for accepting its insistent message as gospel.

Like pirate treasure buried beneath the Statue of Liberty or the private subway stop hidden under the Waldorf-Astoria, gustatory abstinence among New York's best dressed is another juicy but false urban myth.

Admittedly, it's not hard to understand how this food-phobic assumption arose and persists. In his 1987 watershed bestseller, *The Bonfire of the Vanities*, author Tom Wolfe caustically christened the well-heeled tribe of Reagan-era Upper East Side women who could never be too rich or too thin as "social X-rays." And like the stylish yet savage author's other indelible masterstrokes of cultural branding, such as "radical chic,"

"the right stuff," and "the me decade,"
his wicked famished-for-fashion label not
only stuck, but its application was quickly
broadened by the public to include virtually
any woman who buys expensive designer
clothes—lots of them—at list price.

Although New York City's rhythms
and economics have drastically changed
since Wolfe's chronicle, a brilliantly
barbed stereotype has an extended shelf life.
Additional reinforcement is provided by
today's runway and print models, most of
whom are several inches shy of curvaceous
from any angle, helping to sustain the belief
that the luxury market still considers green
tea a core food group.

And yet visit any of Bergdorf Goodman's
seven selling floors: not only is the mesmerizing
landscape composed of the best curated, most
covetable fashion sourced from every corner
of the globe, but it's also populated by stylish
women of a heartening diversity in height;
waistline; haircut and color; bust, shoe, and
dress size; ethnicity and race. These same

women stand united, however, in the invigorating yet exhausting pursuit of the perfect purchase — or four. And all have come to Fifth Avenue and Fifty-eighth Street confident they will find it.

Nevertheless, however thrilling Lanvin's and Tom Ford's most recent collections may be, at some point even the most stalwart shopper's strength is destined to falter. Happily, at Bergdorf Goodman, the savviest course of action is but a button away. Get into the elevator and push "7." And when the doors open, you will instantly discover that BG Restaurant is far more than a handy destination.

BG is a harmoniously realized and relatable oasis, smoothly driven by the conviction that eating on the run is as foolhardy as shopping against the clock. Designed by Kelly Wearstler, the restaurant is handsome yet instantly welcoming, as a salon in your duplex would be, say, if you lived opposite "the Park" (New Yorkers never call it "Central Park") on Fifth (they never say "Avenue" either), and its windows reveal one of the most glorious and rare public views of that park the city has to offer.

But the most vibrant aspect of BG's decor is its guests: enviably clad and coiffed women and men from near and far. There are natives who know their way around every inch of the city, deep in discussion about the knockout installation at SoHo's New Museum. And there are women who took the train in for an afternoon spree who are nearly breathless over Manolo Blahnik's divine new pumps on 2. And if you could only catch more of the dishy conversation between the two women sitting at the table against the window, it would be worth an embarrassing blush, but you can't because they're sitting in the restaurant's signature high-backed, enveloping "whisper" chairs. Jewelry flashes and bags of every shape and skin are as plentiful as butter knives. The place vibrates like a private club that's just declared open membership. The whizzes at Pixar could not animate a livelier scene.

And what do all these excited shoppers have in common? They're eating—and not pinky-up stuff either. When you are in the middle of a city that rightfully boasts some of the finest

and most diverse cuisine in the world, you have to be competitive. BG's menu is as big and bold as a true New Yorker's appetite for fashion, for food, for life, featuring legendary favorites such as Ahi Tuna Tartare, the Gotham Salad, and Lobster Napoleon, not to mention the restaurant's addictive array of desserts and what may be the loveliest afternoon tea service in town. Just as there is only one Bergdorf Goodman, there is only one BG.

This is food meant to be relished rather than tasted. Not surprisingly, the restaurant's regulars have responded with such gusto and curiosity about its fare that it made perfect sense to assemble *The Bergdorf Goodman Cookbook*, an appreciation of and a way to re-create the restaurant's most popular delights. This book contains not only the best recipes from BG's kitchen but also many from fashion and beauty luminaries. From renowned designers, editors, and makeup wizards—you know, all those folks who supposedly don't eat—come recipes for Caramelized Onion and Fontina Cheese Pizza, Matzo Ball Soup with

Carrots and Dill, Baked Mashed Potatoes with Hemingway Trout, Chicken Paprikash with Spätzle, Bread Pudding with Peaches and Caramel Sauce, French Apple Tart, and even my own Hal's Hot for Chili. Not one of them contains flaxseeds.

Food, like fashion, is the most fun you can have with your clothes on. No wonder some of Bergdorf's best customers wish they could live inside the store—it offers the best of both worlds. In fact, there once was an apartment on the top floor of Bergdorf's, but it's gone. Taking up residence is no longer in the realm of possibility. However, being able to re-create the food at BG Restaurant in your own home is now one of the city's most delicious realities.

—Hal Rubenstein

Introduction

Since opening its doors in 1901, Bergdorf Goodman has been a beacon for fashion lovers from around the world. Housed in a beautiful nine-story Beaux Arts building that anchors the northwest corner of Fifth Avenue and Fifty-eighth Street in New York City, the store represents the pinnacle of style, service, and modern luxury. It's the ultimate place to shop for the most exquisite designs, and though it counts all manner of royalty among its clientele—from Princess Grace to Beyoncé—anyone who slips through its revolving doors is immediately welcomed by the warm and attentive staff.

There are few places that better evoke heaven on earth, making Bergdorf's the go-to destination for everything from the perfect red lipstick to a made-to-measure suit to the season's hottest trends. Whether they're indulging in a full day of shopping or just stopping in for lunch, guests make a beeline for one of the store's most popular spots: the BG Restaurant. This inviting space with stunning Central Park views is a

light-filled sanctuary that offers respite and refreshment. Los Angeles–based interior designer Kelly Wearstler created its soothing pale blue and cool green interiors, with hand-painted de Gournay chinoiserie wallpaper and comfortably low-slung chairs that give it the intimate feel of an elegant residence. Though an integral part of the store, BG is a world apart, with its own distinctive energy that keeps the mood light and spirits high.

In addition to attracting local shoppers, international visitors, and the fashion cognoscenti, the restaurant draws many from the New York area, including those who love to soak up the ambience and meet there frequently, or to celebrate important milestones. A day of shopping with lunch at BG is a time-honored rite of passage, one that often becomes a much-repeated tradition for mothers and daughters from around the world. The restaurant also serves as something of an executive dining room for nearby offices—Estée Lauder, Chanel, and Hearst—and quite a few agents and editors in

the book and magazine industries are regulars, too. Though the window seats overlooking the park are highly coveted, the best views in the room are arguably those of the parade of interesting people and fashions inside.

The restaurant's menu features what today's diners want: healthy choices with a touch of indulgence. There is an emphasis on cooking with only the freshest and finest-quality ingredients, sourced in season from local purveyors whenever possible. In keeping with the overall philosophy of the store, careful attention to impeccable presentation prevails.

Though BG is the jewel in the store's culinary crown, there is also Good Dish, a cafe in the downstairs Beauty Level. Each of these venues offers a version of the same elevated cuisine within a similarly stylish context, so simply replicating the recipes at home may not entirely conjure up the same elegant experience—but it comes close.

As Proust reminded us with his famous madeleine, a mere morsel can be evocative enough to transport us to another place and

time. That indelible moment of biting into BG's White Chocolate Bread Pudding while gazing out at the treetops of Central Park below—that luxurious feeling of rapture—could very well come rushing back in your own dining room. And that's really what this cookbook is all about. Whether you live in Tribeca, Tacoma, Toronto, or Taipei, not only can you re-create your favorite recipes from BG, but you also get a glimpse into the kitchens of some of fashion's most famous designers, stylists, executives, and editors. They have generously shared what they like to cook best, including family recipes and foolproof dishes for entertaining. This is the ultimate insider access to BG and to what quite literally fuels the creativity and passion of the world of fashion and modern luxury.

1

Cocktails

Originally known as a "sling" and defined as any drink made with spirits, sugar, and water, the cocktail was introduced in the late 1700s. It became widely popular over the ensuing century, when variations grew to include the whimsically named highballs, punches, fizzes, sours, juleps, cobblers, toddies, and flips that survive to this day. These original formulas laid the foundation for an existing repertoire that has remained the basis for endless tinkering by generations of mixologists. Armed with muddlers, swizzle sticks, and an arsenal of homemade syrups and bitters, today's shaker-wielding wizards are crafting quaffs of unprecedented depth and sophistication.

At BG, where an air of festivity and indulgence generally prevails, the sound of Champagne corks popping is hardly uncommon. In fact, it's not unusual for a flute or two to make its way

into a dressing room, should a customer want
a pick-me-up or need to celebrate an especially
noteworthy occasion. In the restaurant,
however, the fine art of cocktail mixing is in
full swing. Classic martinis and manhattans
that hearken back to the heyday of Madison
Avenue's Mad men have been joined by new
concoctions that make excellent use of artisanal
spirits and bitters. From the fashion crowd's
favorite Champagne-topped Passionista to the
briskly refreshing Central Park, BG's menu
offers no shortage of stylish cocktails to serve at
home. The majority of those included here can
be whipped up for a solitary drink or doubled
for an intimate tête-à-tête, and some can even
be scaled up to serve a holiday crowd. Though a
few of the recipes specify a particular brand of
liquor, these are merely a suggestion. Of course,
as all of BG's offerings indicate, the finest
quality delivers the most memorable results.

THE PASSIONISTA

Makes 1 cocktail

The exotic sweetness of passion fruit combined with the delicate sparkle of Champagne has made this colorful cocktail among the all-time favorites at BG. A perfect balance of tart and sweet, it really enhances a moment of celebration.

1½ ounces vodka
1½ ounces passion fruit purée
½ ounce cranberry juice
¼ ounce fresh lemon juice
1½ ounces brut Champagne
½ slice of orange

Mix the vodka, passion fruit purée, cranberry juice, and lemon juice in a highball glass. Add a scoop of ice. Top with Champagne and garnish with the orange slice.

THE UPTOWN MANHATTAN

Makes 1 cocktail

The manhattan has been a New York City classic since the 1870s, and BG elevates it to meet uptown standards with the inspired addition of cherry liqueur and cardamom bitters. This cocktail's fruity complexity is echoed by a delicious trio of brandied cherries.

1½ ounces Bulleit rye whiskey
½ ounce Carpano Antica Formula
 sweet vermouth
½ ounce Heering cherry liqueur
2–3 dashes of Scrappy's cardamom
 bitters
3 brandied cherries
Small piece of candied ginger

Fill a cocktail shaker with ice and add the whiskey, vermouth, cherry liqueur, and bitters. Shake vigorously and strain into a martini glass. Spear the cherries and ginger on a cocktail skewer and use as a garnish.

THE GOODMAN

Makes 1 cocktail

Just as many designers reserve their black labels to connote premium tailoring, the Johnnie Walker used in this recipe is an example of the finest artistry. The scotch's buttery smokiness is offset by the sharp flavors of ginger and citrus.

2 ounces Johnnie Walker Black Label
 scotch whiskey
¼ ounce Honey Syrup (recipe follows)
½ ounce Ginger Syrup (recipe follows)
1½ teaspoons fresh lemon juice
⅓ cup fresh grapefruit juice
2 dashes of Peychaud's bitters
Twist of lemon peel

HONEY SYRUP
1 cup honey
1 cup water

GINGER SYRUP
¼ pound fresh ginger, peeled
 and thinly sliced
1 cup sugar
1 cup water

Fill a cocktail shaker with ice, then add the whiskey, syrups, juices, and bitters. Shake and serve on the rocks. Garnish with the lemon peel.

TO MAKE THE HONEY SYRUP: Warm the honey and water in a small saucepan over low heat until the honey is fully incorporated, 1 to 2 minutes. Cool to room temperature, then store in the refrigerator.

TO MAKE THE GINGER SYRUP: Bring the ginger, sugar, and water to a slow simmer in a small heavy saucepan over medium-low heat, stirring until the sugar has dissolved. Continue to simmer gently, uncovered, for 30 minutes. Strain through a sieve and discard the ginger, or reserve for another use. Cool to room temperature, then store in the refrigerator.

THE CENTRAL PARK

Makes 1 cocktail

Always on the lookout for cutting-edge labels, BG supports small, independent distillers like Cacao Prieto in Red Hook, Brooklyn. Cacao Prieto's bourbon is made with limestone-rich water from the Widow Jane Mine in the Catskill Mountains and has a spicy sweetness that stands out in this refreshing cocktail.

1½ ounces Widow Jane bourbon
3 ounces freshly brewed iced tea, chilled
1 ounce Ginger Syrup (page 22)
Small piece of candied ginger

Fill a highball glass with ice. Stir in the bourbon, iced tea, and Ginger Syrup. Garnish with the candied ginger.

THE BREUCKELEN ORANGE

Makes 1 cocktail

In the tradition of classic European gins, the highly aromatic Glorious Gin contains essences of juniper, lemon, rosemary, ginger, and grapefruit. It pairs quite well with the bittersweet notes in the aperitifs and the orange.

2 slices of orange
1 ounce Breuckelen Distilling Company Glorious Gin
1 ounce Cynar
1 ounce Carpano Antica Formula sweet vermouth

Muddle 1 of the orange slices in a cocktail shaker, then add the gin, Cynar, and vermouth. Shake with ice and strain into a coupe glass. Garnish with the remaining orange slice.

LYCHEE MARTINI

GEORGINA CHAPMAN, COFOUNDER AND DESIGNER, MARCHESA

Makes 1 cocktail

Marchesa's sumptuous designs regularly grace Hollywood's red carpets, so it's no wonder Georgina's favorite cocktail is all elegant refinement with a dash of exotic glamour. "This is a fun and easy drink I like to make for my guests during the holidays," she says. "It's festive and delicious."

2 canned lychees in syrup, plus a splash of reserved syrup from the can
2½ ounces vodka
Small splash of white vermouth

Put 1 of the lychees in a cocktail glass and place the glass in the freezer for 20 minutes. Put the remaining lychee into a cocktail shaker, along with a handful of ice cubes and the lychee syrup, vodka, and vermouth. Shake vigorously for 30 seconds. Strain into the iced glass and serve with swizzle sticks, if desired.

THE BOBBY

Makes 1 cocktail

BG's riff on the Bobby Burns cocktail, whose origins some trace to the Waldorf Hotel, substitutes bourbon for scotch and the more sophisticated Drambuie for the usual Benedictine. The result is a decidedly smoother drink that goes down well any time of day.

1½ ounces Bulleit bourbon
½ ounce Carpano Antica Formula
 sweet vermouth
1½ ounces Heering cherry liqueur
½ ounce Drambuie
Slice of orange peel

Fill a rocks glass with ice. Place all the liquid ingredients in an ice-filled cocktail shaker and shake well. Strain into the rocks glass. Twist the orange peel over the surface of the drink to release the oils and drop it in.

THE PARADISE ISLAND

Makes 1 cocktail

A distant cousin to the classic sidecar, this original cocktail unites both rum and cognac with the luxurious sweetness of maple syrup. The rum and a hint of lime allude to the exclusive tropical getaway from which this drink takes its name.

1½ ounces 10 Cane rum
1 ounce Hennessy VSOP
1 ounce pure maple syrup
1 ounce fresh lime juice

Shake all the ingredients in a cocktail shaker filled with ice. Strain into a coupe glass and serve.

SPICY GRAPEFRUIT MARGARITA

Makes 1 cocktail

The extra step required to create a jalapeño-infused tequila is just one secret of this delicious cocktail. The other is coating the rim of the glass with a piquant seasoned salt. Together, they build layers of compelling flavor. Scale this recipe up to make a pitcherful when entertaining.

Spicy Salt (recipe follows)
Wedge of lime
1½ ounces Jalapeño-Infused Tequila
 (recipe follows)
½ ounce Cointreau
1 ounce fresh lime juice
2 ounces fresh ruby red grapefruit
 juice
Wedge of grapefruit

SPICY SALT

1 tablespoon kosher or coarse sea salt
1 tablespoon Old Bay seasoning
1 tablespoon Colman's mustard powder

JALAPEÑO-INFUSED TEQUILA

1 750 ml bottle Patrón Silver tequila
 or similar tequila blanco
3 jalapeños

Spread the salt on a small plate. Squeeze the lime wedge and swipe it over the rim of a highball glass. Press the moistened rim of the highball glass into the salt, coating it evenly. Fill the glass with ice.

Fill a cocktail shaker with ice. Add the tequila, Cointreau, lime juice, and grapefruit juice and shake well. Strain the cocktail over the fresh ice and garnish with the grapefruit wedge.

TO MAKE THE SPICY SALT: Mix the ingredients together in a bowl. Any extra may be stored indefinitely in an airtight container.

TO MAKE THE JALAPEÑO-INFUSED TEQUILA: Pour out 1 shot (approximately 1½ ounces) from the tequila bottle. Cut the jalapeños in half, discard the seeds, and thinly slice. Drop the jalapeño slices into the tequila bottle and allow them to infuse for 2 to 3 days before straining and discarding them.

MULLED WINE

KEREN CRAIG, COFOUNDER AND TEXTILE DESIGNER, MARCHESA

Serves 6

Named for an eccentric Italian aristocrat, Marchesa is distinguished by Keren's artful and luxurious textiles. When it comes to holiday entertaining, however, the designer opts for something cozy and classic. "My mum and I serve this every Christmas Eve," she says. "It's very quick to make and the kitchen smells delicious and festive from all the cloves."

1 750 ml bottle fruity red wine
1 cup black tea, or to taste, at room temperature
1 whole orange stuck with 12 cloves
½ cup (packed) light brown sugar
1½ teaspoons ground cinnamon
½ teaspoon grated nutmeg
½ teaspoon ground allspice
½ teaspoon ground ginger
1 cup whiskey, rum, brandy, or vodka

Put the wine, tea, orange, sugar, cinnamon, nutmeg, allspice, and ginger in a medium saucepan and heat without boiling for 30 minutes. To enhance the orange flavor, muddle the orange slightly. To dilute the level of alcohol, increase the amount of tea. Add the whiskey just before serving. Spices will settle near the bottom of the pan, so use a strainer when pouring out the last bit.

2

Hors d'Oeuvres

I n his first book, *Hors d'Oeuvre and Canapés*, culinary titan James Beard explored the full variety of what he called "small, hasty bites" or, in his own private vernacular, "doots." Intended to awaken the appetite but not sate it, the perfect hors d'oeuvre was meant to remain, as its literal translation from French indicates, "outside the main course." Since the publication of Beard's book in 1940, a time when crawfish barquettes and anchovy cheese fingers were popular, this realm of tantalizing morsels has evolved to offer more sublime tastes and textures, like bruschetta and tuna tartare. And in the current era of grazing and small plates, where glorified snacks constitute a meal, the hors d'oeuvre often takes center stage. Formerly intended to sustain guests during the wait before dinner, the hors d'oeuvre has now helped elevate the cocktail hour into the main event.

Nowhere is this in greater evidence than at the collection launches, receptions, and parties hosted at Bergdorf Goodman. At these

festive gatherings—many of them held in the restaurant—designers and guests are feted in style as they mix and mingle, often taking time to peruse the upcoming season's collections. The Champagne flows freely and the mood is upbeat, with servers passing trays of delectable bites that tread the fine line between light and satisfying, healthy and indulgent. BG's hors d'oeuvre repertoire features comforting classics, such as Crab Cakes with Spicy Rémoulade and creamy Deviled Eggs, as well as newer incarnations, like Miniature Mushroom Risotto Cakes and Truffled Grilled Cheese Sandwich Bites.

The recipes in this chapter include many delicious favorites, each of them the perfect embodiment of Bergdorf Goodman's sophisticated spirit. Whether you're entertaining an informal group, hosting a wine tasting, or throwing an extravagant cocktail party, a selection of these hors d'oeuvres—most of them quite simple to create, even for the fledgling cook—will surely delight your guests.

CRAB CAKES WITH SPICY RÉMOULADE

Makes 25 cakes

The hallmark of a good crab cake is pristine lump crabmeat and little else. At BG, chunks of the very freshest crab are bound together with a little mayonnaise and panko, the Japanese bread crumbs known for their light and crunchy texture. A dollop of classic French rémoulade sauce is the perfect accessory.

3 tablespoons olive oil
¼ cup finely diced red bell pepper
¼ cup finely diced red onion
1 pound jumbo lump crab, carefully
 picked through for shells
½ cup best-quality mayonnaise
2 tablespoons Dijon mustard
1 large egg, beaten
3 tablespoons fresh lemon juice
2 cups panko (Japanese bread crumbs)
Pinch of cayenne
Salt and freshly ground black pepper

1 tablespoon unsalted butter, for frying
Spicy Rémoulade Sauce (recipe
 follows)

SPICY RÉMOULADE SAUCE
1 cup best-quality mayonnaise
¼ cup Dijon mustard
2 tablespoons capers
¼ cup diced tomato
2 teaspoons Sriracha or other red
 chili sauce
Salt and freshly ground black pepper

Heat 1 tablespoon of the oil in a small skillet over medium-low heat. Add the bell pepper and onion and sauté until soft, 5 to 10 minutes. Cool to room temperature.

In a large bowl, mix together the bell pepper–onion mixture, crab, mayonnaise, mustard, egg, lemon juice, 1 cup of the panko, the cayenne, and salt and freshly ground black pepper to taste. Pour the remaining cup of panko on a plate. Form the crab mixture into 25 2-inch-thick patties. Dredge the crab cakes in the panko, place on a plate, and cover with plastic wrap. Refrigerate at least 30 minutes before cooking.

Place a rack in the middle of the oven and preheat to 250°F.

Cover a baking sheet with foil and set aside. Heat the butter and the remaining oil in a large nonstick skillet over medium heat. Working in batches, pan-fry the crab cakes until golden on one side, 3 to 4 minutes, then flip them and reduce the heat to medium-low. Continue cooking for another 2 to 3 minutes. Remove the crab cakes to the baking sheet and keep warm in the oven while you prepare the rest. Serve with a dollop of the rémoulade.

TO MAKE THE SPICY RÉMOULADE SAUCE: In a food processor, blend the mayonnaise, mustard, capers, tomato, and Sriracha. Season to taste with salt and pepper.

TRUFFLED FINGERLING CHIPS

Serves 6 to 8

Arguably the most addictive snack in the world, BG's potato chips transcend anything store-bought. Freshly fried and drizzled with white truffle oil, they are the couture version of this all-American classic. If you have an electric deep fryer, by all means use it, but a stovetop version works just fine.

4 cups peanut oil or neutral vegetable oil, for frying
1 pound fingerling potatoes
3 tablespoons white truffle oil
Sea salt

In a large stockpot, heat the peanut oil over medium-high heat until it registers 350°F on a deep-fat thermometer. Line a large plate or baking sheet with paper towels for the finished chips.

Slice the potatoes very thinly, using a sharp knife or mandoline. Make only about 12 slices at a time, so they don't discolor. Fry in batches until evenly golden, about 2 minutes.

Using tongs or a spider, remove the chips from the peanut oil and place on the plate to drain. Lightly drizzle with truffle oil and sprinkle generously with sea salt. Serve immediately.

DEVILED EGGS

Makes 12 hors d'oeuvres

The deviled egg can be found in recipes dating as far back as Roman antiquity, and this creamy, curry-infused version remains eternally popular at BG. As the saying goes, "the devil is in the details," so round up the best-quality ingredients and add your own flair with a colorful garnish.

6 large eggs
3 teaspoons best-quality mayonnaise
2 teaspoons sweet pickle relish
1 teaspoon curry powder
½ teaspoon Tabasco sauce, or to taste
Pinch of kosher salt
Fresh parsley, paprika, or pancetta crisps (optional)

Place the eggs in a large saucepan and cover with cold water. Bring the water to a gentle boil, cover, remove from the heat, and set the timer for 10 minutes. Rinse the eggs under cold water and peel off the shells.

Cut the eggs in half. Gently remove the yolks and put them in a food processor. Set the whites on a plate, hollow side up.

Add the mayonnaise, relish, curry, Tabasco, and salt to the yolks and process until smooth. Place the yolk mixture in a piping bag and pipe into the egg-white halves. (If you don't have a piping bag, simply spoon the yolk mixture into a small plastic bag and snip off a tiny corner.) Garnish each with a sprig of fresh parsley, a pinch of paprika, or a pancetta crisp (if desired).

SMASHED AVOCADO SALSA

DANA COWIN, EDITOR IN CHIEF, *FOOD & WINE* MAGAZINE

Serves 4

While writing her cookbook, *Mastering My Mistakes in the Kitchen*, Dana threw a big party to test some of her recipes. "This guacamole came about when I decided to toss in a load of salsa from the hors d'oeuvre table," she says. "Finally, I had a dip with some spunk!" The addition of fresh jicama gives this delicious dip a juicy crunch.

1 cup yellow and red cherry tomatoes, chopped
½ cup diced peeled jicama
2 tablespoons thinly sliced scallions (white and light green parts only)
¼ jalapeño, seeded and finely diced
2 tablespoons finely chopped fresh cilantro
1½ tablespoons fresh lemon juice
1 ripe Hass avocado, pitted, peeled, and roughly diced
¼ teaspoon salt
Tortilla chips, for serving

In a large bowl, combine the tomatoes, jicama, scallions, jalapeño, cilantro, and lemon juice. Add the avocado and lightly smash with a fork so that the mixture is not entirely smooth but most definitely scoopable with a chip. Add the salt. Serve immediately with plenty of tortilla chips.

ONE-BITE FALLEN CHEESE SOUFFLÉS

Makes 16 hors d'oeuvres

A variation on the classic French cheese puffs known as *gougères*, these little soufflés are elegant in appearance yet incredibly simple to make. They freeze quite well, too, so they can be made ahead of time and reheated right before serving.

3 tablespoons finely grated Parmesan cheese

2 tablespoons (¼ stick) unsalted butter, plus extra to grease tins

2 tablespoons all-purpose flour

½ cup whole milk

½ cup finely grated Gruyère cheese

Pinch of cayenne

2 large eggs, separated

⅛ teaspoon salt

2 tablespoons finely chopped fresh chives

Place a rack in the middle of the oven and preheat to 350°F.

Grease 16 mini-muffin tins with butter. Dust with Parmesan and tap to remove excess, reserving any extra.

In a medium saucepan over medium heat, melt the butter, then stir in the flour and cook for 1 minute. Whisk in the milk and bring to a boil, stirring constantly. Remove from the heat and stir in the Gruyère and remaining Parmesan until the cheeses melt. Add the cayenne and slowly whisk in the egg yolks.

Beat the egg whites with the salt just until peaks form. Fold the whites into the base mix and gently stir in the chives. Spoon the mixture into the tins and bake until puffed high, 12 to 15 minutes. The soufflés will fall quickly once removed from the oven but can be reheated at 350°F for 10 minutes right before serving, and they will puff back up slightly.

HERBED POLENTA COINS
with WILD MUSHROOMS
and TALEGGIO

Makes about 50 hors d'oeuvres

Ideal for a cocktail party or to fortify a group of guests before dinner, these vegetarian mouthfuls are deeply savory, thanks to umami-rich wild mushrooms and pungent Taleggio. This polenta is best started a day ahead, as it needs to firm up overnight in the refrigerator.

2 teaspoons salt, plus extra for seasoning
1¾ cups yellow cornmeal
3 tablespoons unsalted butter
2 cups fresh basil leaves, loosely packed
1–2 garlic cloves
2–4 tablespoons olive oil, plus extra for cooking mushrooms
½ cup grated Parmesan cheese

1½ cups finely chopped assorted fresh wild mushrooms, such as any combination of chanterelles, morels, black trumpets, hen of the woods, and porcini
Salt and freshly ground black pepper
¼ pound Taleggio cheese, diced into ½-inch pieces

ON DAY ONE, prepare the polenta. Bring 6 cups of water to a boil in a large, heavy saucepan. Add the salt. Gradually whisk in the cornmeal. Reduce the heat to low and cook until the mixture thickens and the cornmeal is tender, stirring often, about 15 minutes. Turn off the heat, then add the butter and stir until melted.

Pour the polenta onto a rimmed baking sheet and spread evenly to a ½-inch thickness. Chill overnight in the refrigerator.

ON DAY TWO, place a rack in the middle of the oven and preheat to 375°F. Line a baking sheet with parchment paper and set aside.

Combine the basil, garlic, and 2 tablespoons of the oil in a blender or mini-processor, streaming in just enough additional oil while blending to turn mixture into a smooth paste. Scrape into a bowl and fold in the Parmesan.

In a small skillet, heat 1 tablespoon oil over medium heat. Add the mushrooms, season to taste with salt and pepper, and cook, stirring occasionally, until softened, about 3 minutes.

Using a round 1½-inch-diameter cookie cutter, cut buttons out of the firm polenta and place them on the baking sheet. Spread a small dollop of the pesto on each polenta coin, then top with a small spoonful of the mushrooms and a piece of Taleggio. Bake until hot, about 10 minutes. Serve immediately.

ROASTED BEET, APPLE, AND CHÈVRE TARTLETS

Makes 24 tartlets

The deep earthiness of roasted beets is often paired with the bright tang of fresh goat cheese, and here, the addition of roasted apple adds a complementary element of sweetness. Served in buttery tart shells, widely available in the frozen section at gourmet stores, this trio really sings.

2 medium beets, oven-roasted, peeled, and chopped into ½-inch cubes
1 large Granny Smith apple
3 tablespoons extra-virgin olive oil
2 tablespoons sugar
2 teaspoons balsamic vinegar

Salt and freshly ground black pepper
24 tartlet shells (2-inch diameter or smaller), prebaked
2 tablespoons chèvre (fresh goat cheese), crumbled
Fresh chervil

Place a rack in the middle of the oven and preheat to 400°F.

Wash the beets, wrap them individually in foil, and place them on a baking sheet. Roast until a knife can pierce the beets with little resistance, 50 to 60 minutes, depending on the size of the beet. Remove from the oven. When the beets are cool enough to handle, peel them and set aside.

Reduce the oven temperature to 375°F. Line a baking sheet with parchment paper. Peel and core the apple and slice it into wedges. Toss in a small bowl with 1 tablespoon of the oil and the sugar, then place on the baking sheet. Roast until golden and soft but not falling apart, about 10 minutes.

In a large bowl, mix the vinegar and the remaining 2 tablespoons oil. Season with salt and pepper. Chop the apple and beets into ½-inch cubes, then combine in the large bowl with the dressing and toss to coat well. Fill the tartlet shells with the beet-apple mixture, sprinkle the goat cheese on top, and garnish each with a sprig of chervil.

MINIATURE MUSHROOM RISOTTO CAKES

Makes 50 cakes

Inspired by *arancini*, the savory rice balls of Sicily, this fabulous finger food is a lighter version that omits the bread crumb coating and deep frying. Lightly browned in a skillet and perfumed with a drop of white truffle oil, they are richly satisfying.

¼ cup olive oil
1½ cups chopped assorted mushrooms, such as a combination of oyster, cremini, and button
½ Spanish onion, finely diced
2 teaspoons minced garlic
½ teaspoon salt, plus more for seasoning

3 cups vegetable stock or water
1 cup Arborio rice
Freshly ground black pepper
¾ cup finely grated Parmesan cheese
White truffle oil

Heat 2 tablespoons of the olive oil over medium heat in a medium skillet. Add the mushrooms, onion, garlic, and ½ teaspoon salt. Cook, stirring often, for 5 minutes. Set aside to cool.

Meanwhile, heat the stock to a simmer in a saucepan; keep hot.

Heat 1 tablespoon of the olive oil in a medium saucepan over medium heat. Sauté the rice for 2 minutes, then reduce the heat to low.

Gradually add the stock in ½-cup increments, stirring constantly after each addition, until the rice is cooked and the liquid is absorbed, about 25 minutes total. Remove from the heat and allow to cool slightly. Season with additional salt and the pepper.

Add the mushroom mixture and ½ cup of the Parmesan, stirring to combine. Spoon the mixture into a rimmed 9 × 13-inch baking sheet; press down on the mixture until it is smooth and even. Cover and refrigerate, a minimum of 4 hours but no longer than 24.

Once the risotto has chilled, cut out rounds using a 1½-inch-diameter cookie cutter. Remold any leftover scraps and repeat until all the mixture has been used.

Heat the remaining 1 tablespoon oil in a large, heavy skillet. Cook the rounds until lightly browned, 1 to 2 minutes per side. Serve warm, sprinkled with the remaining ¼ cup Parmesan and a drop of truffle oil.

TRUFFLED GRILLED CHEESE SANDWICH BITES

Makes 24 hors d'oeuvres

What BG is to the world of fashion, truffles are to fine cuisine: the pinnacle of luxury. Though it may seem impossible to improve upon the classic grilled cheese sandwich, this version truly does. Lavished with both French black truffles and white truffle oil, it's irresistibly chic.

6 ounces Robiola Osella or Taleggio cheese
3 tablespoons white truffle oil
2 tablespoons chopped jarred black truffles
Salt and freshly ground black pepper
4 4½-inch-wide lengthwise slices best-quality white or brioche loaf, crust removed
Melted butter

Place a rack in the middle of the oven and preheat to 350°F.

Dice the cheese into small cubes and mix with the oil and truffles. Season with salt and pepper.

Spread half the cheese mixture on 1 slice of bread and half on another, then top with the remaining 2 slices.

Generously coat a baking sheet with butter and place the sandwiches on top. Spread the top layer of bread with more butter.

Place a second baking sheet on top of the sandwiches and bake until golden brown, 12 to 15 minutes.

Remove the sandwiches from the oven and carefully transfer to a cutting board. Slice into 1½-inch squares. Drizzle a little more white truffle oil on top and serve.

These are delicious with Tomato-Fennel Soup (page 72).

FENNEL, CHICKPEAS, AND APPLE ON SEMOLINA RAISIN TOAST

Serves 12

The original inspiration for this snack was the bread—BG uses a signature loaf from New York's legendary Amy's Bread, made with semolina, golden raisins, and fennel seeds—but any good-quality raisin bread may be substituted. The topping, an appealing combination of toothsome and creamy, gets a boost of protein from the chickpeas.

2 tablespoons unsalted butter
1 Granny Smith apple, cored and
 diced small
1 small fennel bulb
2 tablespoons extra-virgin olive oil
1 cup canned chickpeas, rinsed
 and drained
2 tablespoons fresh lemon juice
Salt and freshly ground black pepper
12 slices semolina raisin bread

Melt the butter in a medium skillet and sauté the apple until tender. Transfer to a large bowl and wipe out the skillet.

Trim the root and the stalk from the fennel and slice very thinly. Heat the oil in the skillet and sauté the fennel until just soft and translucent. Add to the apple, then stir in the chickpeas and lemon juice. Season with salt and pepper.

Toast the bread, spoon the chickpea mixture evenly over each slice, and serve.

SMOKED SALMON BRUSCHETTA
with CRÈME FRAÎCHE, CAPERS, and DILL

Makes 16 pieces

This superb combination is a classic. The silky texture and rich smokiness of the salmon make this delicacy the perfect foil for the cool tang of crème fraîche and the piquant flavor of capers. It's best served with an ice-cold vodka martini.

1 small baguette

4 tablespoons extra-virgin olive oil

2 ounces crème fraîche

1 pound smoked salmon, thinly sliced into 1-inch ribbons

2 tablespoons chopped capers in vinegar

16 sprigs of fresh dill

Place a rack in the middle of the oven and preheat to 375°F.

Cut the baguette into ¼-inch-thick slices and drizzle with the oil. Toast in the oven until crisp, about 10 minutes, turning once. Remove from the oven and transfer to a serving tray.

Spread a spoonful of crème fraîche on each toasted slice, followed by ribbons of salmon. Top with capers and a sprig of dill.

SALMON MOUSSE

NANCY NOVOGROD, FORMER EDITOR IN CHIEF,
TRAVEL + LEISURE MAGAZINE

Makes 1 pint

Nancy, the daughter of a retailer who didn't cook, really knows her way around the kitchen. She found a version of this recipe in a vintage community cookbook and updated it to her liking, and it's become a staple for entertaining. "I make the mousse a lot, including for Easter at our friends' house," she says. "In fact, it may be the reason we've been invited back for so many years!"

½ pound smoked salmon
1½ tablespoons fresh lemon juice
8 tablespoons (1 stick) unsalted butter, melted and brought to room temperature
1 cup heavy cream
Fresh dill

Blend the salmon in a food processor, adding the juice, butter, and cream one ingredient at a time until well combined and very smooth.

Store in the refrigerator. Allow to come to room temperature before serving. Garnish with a few sprigs of dill and serve with thinly sliced dark or whole-grain bread.

3

Soups and Starters

There are occasions when a certain pomp and circumstance are called for at the dinner table. And then there are those informal gatherings—casual tête-à-têtes and weeknight dinners with the family—that require less effort. Where once formal entertaining at home was the norm— along with frilly aprons and place cards—we no longer have to concern ourselves with preparing an intricate series of courses. The great thing about the flexibility of modern dining is that we can structure our meals as we please. So, although soups and starters make ideal first courses, they can also be mixed and matched to create lunches, light snacks, or even satisfying and elegant dinners.

None of the many editions of *Joy of Cooking*, the classic tome renowned for solutions to every culinary conundrum, has ever included a chapter of first courses. It simply advises the

cook to envision a meal in its entirety in order to create a balanced and pleasing progression. Whether you begin with a light cup of soup or a mound of fresh cheese on toast, or whether these dishes are meals unto themselves is entirely dependent on your mood and the amount of time at your disposal for both cooking and eating.

Among BG's varied options—from a rich and hearty Lobster Mac and Cheese to a light and nourishing Velvety Green Pea Soup—there is something to suit virtually every occasion and appetite. Diners at the restaurant can decide what and how they want to eat, putting together their meals according to their own cravings and schedules. You can do the same, whether planning a dinner party or whipping up a midnight snack. A starter can be a point of departure or an end unto itself. It's largely a matter of personal style.

AHI TUNA TARTARE

Serves 4

The popularity of tuna tartare among the fashion set has remained constant for decades, and many BG customers crave this addictive rendition, made with avocado and pine nuts. Spicy wasabi is delivered both in the creamy sauce and in the tobiko, tiny flying fish roe that adds a subtle crunch. Building this dish inside a ring mold is the secret to its elegant presentation.

1 pound sushi-grade yellowfin tuna, finely diced by hand
1 tablespoon Tabasco sauce
2 tablespoons finely chopped fresh parsley
Salt and freshly ground pepper
2 tablespoons pine nuts, lightly toasted
1 ripe avocado, pitted, peeled, and finely diced
½ teaspoon wasabi powder
3 tablespoons crème fraîche
1 ounce green wasabi-flavored tobiko
4 sprigs of fresh chervil
Handful of wonton crisps

Mix the tuna with the Tabasco and parsley and season with salt and pepper.

Line a baking sheet with parchment paper. Place four 4-inch ring molds on the baking sheet. Scatter ½ tablespoon of the pine nuts over the bottom of each ring mold. Fill each mold halfway with tuna and press down lightly with the back of a spoon to compact. Add 2 tablespoons of avocado to each mold, then add the remaining tuna mixture. Press down again with the spoon to compact, and remove the ring to unmold. In a small bowl, combine the wasabi powder and crème fraîche, then whisk in a few drops of water to make a creamy consistency.

To serve, drizzle a few lines of wasabi crème on each of 4 plates. Place a tuna tartare tower on top and decorate with a little tobiko. Garnish with a sprig of chervil and a few wonton crisps.

RICOTTA TOASTS

JANE LARKWORTHY, BEAUTY DIRECTOR, *W* MAGAZINE

Serves 6 to 8

Jane is an arbiter of all things beautiful, and her impeccable taste extends to the culinary realm. When she and her husband, Bertrand, come across a dish they love, they often try to replicate it at home. Jane credits this particularly beloved recipe—"re-created blindly, through memory and taste buds"—to her friends Christine and Oliver. Now it's always on the menu when she entertains.

1 loaf of good-quality country bread, sliced into 12 ¾-inch-thick pieces

¼ cup white truffle oil, plus extra for drizzling

2–3 garlic cloves, smashed

1 pound fresh ricotta

24 fresh sage leaves, roughly chopped

Flaky sea salt

Place a rack in the middle of the oven and preheat to 350°F. Line a baking sheet with parchment paper and set aside.

Lightly toast the bread slices in the toaster. Set aside on a cutting board.

Brush truffle oil on one side of each piece, gently rub each with a crushed garlic clove, then spread a dollop of ricotta on top. Garnish with a sprinkle of sage. Place the toasts on the baking sheet and bake for 10 minutes. Remove from the oven and drizzle each with a drop or two of oil. Add a pinch of salt to each toast and serve immediately.

GRILLED CROUSTADES WITH GARLICKY KALE AND BURRATA

Serves 8

BG responded to the kale craze with this satisfying starter, which has gone on to achieve classic status. A Mediterranean mix of braised vegetables is piled on top of creamy burrata cheese. To accommodate guests with allergies, the restaurant uses a nut-free pesto, but this dish would also work well with one made with pine nuts or walnuts.

1 pound grape tomatoes, halved

3 tablespoons extra-virgin olive oil

8 thick slices of sourdough bread

2 garlic cloves, minced

Large bunch of fresh kale, thick stems removed, washed, dried, and roughly chopped (5 to 6 cups)

½ cup dry white wine

1 12-ounce jar roasted red peppers, drained and thinly sliced

½ cup Niçoise olives, pitted and roughly chopped

½ cup pesto

1 pound burrata or fresh mozzarella cheese, sliced into 8 pieces

Place a rack in the middle of the oven and preheat to 400°F. Line a baking sheet with parchment paper and set aside.

In a medium bowl, toss the tomatoes with 1 tablespoon of the oil. Spread in a single layer on the baking sheet and roast for 20 minutes. Remove from the oven and cool. Meanwhile, toast the sourdough bread until crispy.

In a medium skillet, warm the remaining 2 tablespoons oil over medium heat and sauté the garlic for 30 seconds. Add the kale and cook until wilted. Pour in the wine to deglaze the pan, cooking until the liquid is absorbed, about 10 minutes. Remove from the heat.

In a medium bowl, mix together the peppers, tomatoes, and olives. To assemble the croustades, drizzle a little pesto onto 8 plates and place a piece of toasted bread on each one. Top with cheese, a pile of kale, and a spoonful of vegetables.

LOBSTER MAC AND CHEESE

Serves 6

Due to popular demand, this rich and wonderfully decadent dish is always on the BG menu. It's often shared by diners who just can't resist tagging it onto their order, and a few bites of this creamy indulgence does go a long way. The addition of fresh lobster and smoked Gouda takes this comfort food to new heights.

8 tablespoons (1 stick) unsalted butter
½ cup all-purpose flour
1 quart whole milk
½ teaspoon ground nutmeg
2 tablespoons salt
½ teaspoon freshly ground black pepper
1 cup best-quality lobster stock
1 cup shredded smoked Gouda cheese
1 pound penne
1½ pounds cooked fresh lobster meat
1½ cups panko (Japanese bread crumbs) or any plain dried bread crumbs

Place a rack in the middle of the oven and preheat to 400°F.

Make a béchamel sauce by melting the butter in a medium saucepan over medium-low heat. Add the flour and cook on low heat for 10 to 15 minutes, whisking constantly until blond in color. Raise the heat to medium and add the milk, nutmeg, salt, and pepper, whisking continually for several minutes, until thick. Add the stock and Gouda, stirring to combine thoroughly. Remove from the heat and set aside.

Prepare the penne according to the package directions, just until al dente. Drain well and return the penne to the pot. Pour the béchamel sauce over the penne and mix in the lobster meat.

To serve, pour into 6 individual ovenproof bowls or a 9 × 13-inch ovenproof casserole and sprinkle the panko on top. Bake for 5 to 10 minutes, until nicely browned and bubbling.

MUSHROOM AND BRUSSELS SPROUT TARTS

Serves 8

These delicious tarts signal the start of an elegant meal. The autumnal combination of mushrooms and Brussels sprouts is paired with judicious amounts of cheese, walnuts, and pancetta for a dish that manages to be rich without overpowering. Serve it before a roasted chicken, or on its own for a fall luncheon.

4 tablespoons (½ stick) unsalted butter

¼ cup diced onion

4 tablespoons all-purpose flour

1 cup whole milk

Salt and freshly ground black pepper

2 sheets of puff pastry, defrosted in the refrigerator

¾ pound baby Brussels sprouts, sliced in half

2 teaspoons olive oil

4 cups sliced assorted fresh wild mushrooms, such as any combination of chanterelles, morels, hen of the woods, black trumpets, and porcini

4 teaspoons chopped pancetta

4 ounces blue cheese, crumbled

4 teaspoons chopped walnuts

¾ cup dried bread crumbs

2 cups microgreens or tender baby greens

Place a rack in the middle of the oven and preheat to 375°F.

In a medium saucepan, make a béchamel sauce: Melt the butter over medium heat and sauté the onion until soft and translucent. Add the flour and cook, stirring, 5 minutes more. Whisk in the milk and keep whisking for 1 minute to prevent lumps. Pass through a fine strainer set over a bowl to remove the onion. Season lightly with salt and pepper. Cool to room temperature and set aside.

Line a large baking sheet with parchment paper. Using eight 4-inch-wide metal baking rings, cut 8 rounds from the puff pastry dough and place them on the baking sheet. Bake for 10 minutes, then remove the rings from the pastry and set the baking sheet aside. As an alternative to the rings, fit the pastry rounds into a lightly greased muffin tin and reduce the time in the oven to 5 to 7 minutes.

Steam or microwave the Brussels sprouts until tender. Place in a large bowl.

In a medium skillet, warm the oil over medium heat and sauté the mushrooms until lightly browned, about 10 minutes. Combine in the bowl with the Brussels sprouts. In the same skillet, sauté the pancetta until crispy, about 5 minutes, then add to the bowl of vegetables along with the blue cheese, walnuts, and ⅔ cup of the béchamel sauce. Taste and add more salt if necessary.

Top each baked pastry round with ⅛ of the mixture and cover with bread crumbs. Bake for 7 to 10 minutes, or until golden brown and bubbling. Garnish with greens and serve.

RIBOLLITA
(TUSCAN BREAD SOUP)

Serves 8

This robust soup dates back to the Middle Ages, when it was a staple of Italian peasants. It's now a beloved vegetarian option that delivers plenty of flavor. Essentially a minestrone "reboiled" (*ribollita*) with toasted slices of rustic bread, the ingredients come together with a generous drizzle of fruity olive oil.

2 tablespoons olive oil
1 small onion, roughly chopped
1 carrot, chopped
1 celery stalk, chopped
3 garlic cloves, smashed
Salt and freshly ground black pepper
Bunch of cavolo nero (Tuscan kale) or
 other kale, thick stems discarded
 and roughly chopped
Small head of green cabbage, cored
 and shredded
2 tablespoons tomato paste
1 15-ounce can whole peeled tomatoes
3 15-ounce cans cannellini beans
Sprig of fresh thyme
4 cups peeled, seeded, and diced
 butternut squash
6 slices of country bread, toasted
½ cup grated Parmesan cheese,
 plus more for garnish
Chopped fresh parsley
Extra-virgin olive oil

In a large stockpot, warm the olive oil over medium heat and add the onion, carrot, celery, and garlic. Season with salt and pepper and stir until tender, about 10 minutes. Add the kale and cabbage and stir until wilted, 4 to 6 minutes. Add 6 cups water, the tomato paste, tomatoes, beans, and thyme and simmer on low for 45 minutes. Add the squash and cover the pot, simmering until the vegetables are tender, another 20 to 30 minutes.

Place the slices of toasted bread in a 9 × 13-inch baking dish. Pour half the soup over the bread and let it absorb for about 15 minutes. Generously sprinkle with most of the Parmesan and set aside.

Before serving, reheat the remaining soup over medium heat. Place a spoonful of the bread mixture in each bowl and ladle breadless soup over to cover. Garnish with a sprinkle of Parmesan, a bit of parsley, and a drizzle of oil.

VELVETY GREEN PEA SOUP

Serves 6 to 8

Though simple and unadorned, this lighter pea soup made with fresh green peas has long been a popular item on the BG menu. The addition of cooked sweet potato helps create its voluptuous texture, as does a very thorough blending.

2 tablespoons olive oil
1½ cups yellow onion, chopped
1 cup chopped celery
1 cup chopped carrots
1 cup chopped peeled sweet potato
1 tablespoon chopped garlic
1 teaspoon salt
½ teaspoon ground white pepper
3¾ cups chicken stock
2 tablespoons soy sauce
1 pound fresh or frozen, thawed
 green peas
½ cup chopped fresh parsley

Heat the oil in a large stockpot over medium-low heat and sauté the onion, celery, carrots, sweet potato, garlic, salt, and white pepper until the vegetables are tender but not brown. Add the stock and soy sauce and bring to a boil. Stir in the peas and blanch for 30 seconds. Turn off the heat. Cool slightly, then add the parsley. In a blender or food processor, and in batches if needed, purée all the ingredients until very smooth. Serve warm.

BUTTERNUT SQUASH SOUP
WITH SAGE CROUTONS

Serves 6

Coco Chanel recommended always removing one item from every ensemble, and BG applies this general principle to its menu. The food is never overly fussy, but when a garnish does appear, its contribution is significant, as with the wonderfully crunchy croutons that accompany this nourishing soup.

6 cups peeled, seeded, and
 diced (1-inch) butternut squash
 (about 2 pounds)
3 tablespoons olive oil
Salt and freshly ground black pepper
2 tablespoons unsalted butter
1 medium yellow onion, coarsely
 chopped
2 celery stalks, coarsely chopped
1 large carrot, coarsely chopped

2 garlic cloves, crushed
4 cups vegetable stock
1 teaspoon chopped fresh thyme
3 cups ¾-inch-thick cubed sourdough
 bread
½ cup grated Parmesan cheese
1 tablespoon minced fresh sage
2 tablespoons heavy cream, warmed
 (optional)

Place a rack in the middle of the oven and preheat to 400°F.

Toss the squash with 1 tablespoon of the oil, 1 teaspoon of the salt, and ½ teaspoon of the pepper and roast in the oven until soft, about 30 minutes. Remove the squash from the oven.

Reduce the oven temperature to 325°F.

In a large saucepan over medium-high heat, melt the butter and sauté the onion, celery, carrot, and garlic until soft, 10 to 15 minutes. Add the stock, thyme, and roasted squash and simmer, covered, for 30 minutes.

Meanwhile, prepare the croutons. Line a baking sheet with parchment paper. In a large mixing bowl, stir together the bread cubes, the remaining 2 tablespoons oil, the Parmesan, and the fresh sage. Spread in a single layer on a baking sheet and toast in the oven until crisp, about 15 minutes. Remove from the oven and cool.

Working in batches, purée the soup in a food processor or blender until smooth. Return to the pan and add the warm cream (if desired). Season with salt and pepper and gently reheat. To serve, ladle into bowls and garnish with the croutons.

BG LOBSTER BISQUE

Serves 4 to 5

Considered among the great luxuries of the seafood world, lobster gets the royal treatment in this rich soup. Using the entire lobster—including the shell—to make a stock ensures that every bit of flavor is extracted, and considerably reducing the stock further intensifies it. Save this recipe for a special occasion, or make it to transform any meal into one.

2 live or cooked lobsters (1¼ pounds each), still in their shells
¼ cup grapeseed oil
1 large onion, roughly chopped
2 medium carrots, roughly chopped
2 celery stalks, roughly chopped
1 head of garlic, cut in half crosswise
3 plum tomatoes, roughly chopped

1 cup cognac
¾ cup dry white wine
¼ cup tomato paste
½ bunch of fresh thyme
2 cups heavy cream
Salt
Pinch of ground white pepper

Bring a large pot of water to a boil. If using live lobsters, add them headfirst and boil for 8 minutes. Using tongs, transfer the cooked lobsters to a large bowl. When cool (or if using a previously cooked lobster), twist off the tails and claws, working over a large bowl or sink. Using a hammer or heavy knife handle, crack the tail and claw shells. Remove and dice the lobster meat; set aside. Coarsely chop the lobster shells and bodies, discarding the head sacs and any roe, and transfer to a large bowl.

In a large stockpot over medium-high heat, warm the oil and add the lobster shells and bodies, onion, carrots, celery, garlic, and tomatoes. Sauté, stirring occasionally, until brown, 10 to 15 minutes. Deglaze with the cognac and scrape the brown bits from the bottom of the pot, mixing everything together. Cook these ingredients until almost dry. Add the wine and reduce again until almost dry.

Cover the mixture with 2 quarts water. Whisk in the tomato paste and add the thyme. Bring to a boil, then lower the heat and simmer gently for 90 minutes, until the liquid is reduced by half.

Pass through a fine mesh strainer, reserving the stock.

Place the cream in a medium saucepan and simmer vigorously over medium heat to reduce by half. Stir into the strained stock and season to taste with salt and the white pepper. Garnish with the reserved lobster meat.

MATZO BALL SOUP with CARROTS and DILL

DARCY MILLER, ILLUSTRATOR AND EDITORIAL DIRECTOR,
MARTHA STEWART WEDDINGS

Serves 8 to 10

What Darcy loves best about her grandmother Dorothy's traditional Passover soup are the many memories it conjures for her. "I would try to sit quietly with my cousins at the beautifully set table while our grandfather read the prayers," she remembers. "Silently, we counted the pages until we could start on our soup!" She recommends leaving the skins on the onions to ensure the golden color of this delicious soup, which requires a 2-day preparation.

RICH CHICKEN BROTH
Makes about 8 cups

2 whole skin-on chickens (3–4 pounds each), quartered, with necks reserved

3 medium yellow onions, unpeeled

4 medium carrots

4 celery stalks

2 bay leaves

10 black peppercorns

½ bunch of fresh dill, separated into about 24 large sprigs

MATZO BALLS
Makes 14 to 15 balls

6 large eggs, separated

1 cup plus 3 tablespoons matzo meal

4½ teaspoons coarsely chopped fresh dill

2 teaspoons kosher salt

⅛ teaspoon freshly ground black pepper

1 teaspoon unsalted margarine or dairy-free spread

1 teaspoon olive oil

¼ cup farfel (available in the kosher section)

Rich Chicken Broth (recipe follows)

40 unpeeled baby carrots (about 1¼ pounds), with stems attached, if possible

TO MAKE THE RICH CHICKEN
BROTH: Rinse the chicken quarters
and necks under cold water and place in
an 11-quart stockpot. Cut the onions,
carrots, and celery in half and add
to the pot along with the bay leaves,
peppercorns, and dill. Add enough cold
water to cover, about 5 quarts.

Bring to a boil, then reduce the heat
to medium-low and simmer for 4 hours,
skimming off any scum that rises to the
surface. Check the pot after the 1-hour
mark, and if the water level has dropped
by more than a third, add 3 to 4 addi-
tional cups of water.

Remove the pot from the heat and
strain the broth through a cheesecloth-
lined sieve, discarding the solids. Cool
to room temperature and refrigerate
overnight.

The following day, remove any solidi-
fied fat from the surface (save for another
use, if desired). The broth can be kept
refrigerated for 2 days or frozen for
2 months.

TO MAKE THE MATZO BALLS:
In a medium bowl, beat the egg whites
until very stiff. Gently mix in the egg
yolks until thoroughly combined.

Sprinkle the matzo meal over the egg
mixture. Add 2 teaspoons of the dill,
1 teaspoon of the salt, and the pepper
and mix well. Refrigerate for about
6 minutes. (For more dense matzo
balls, refrigerate for longer.)

Meanwhile, heat the margarine and
oil in a small skillet over medium-high
heat. Add the farfel and toast until
golden brown, tossing occasionally,
for 3 to 4 minutes. Set aside in a
small bowl.

Wet your hands and form 2 table-
spoons matzo mixture into a 1-inch
ball. Place on a plate and continue the
process with the rest of the mixture,
wetting hands as necessary.

(continued on next page)

TO PREPARE THE SOUP: Set aside 8 cups of the broth to be used for the soup. Add water to the remainder to make 8 additional cups of liquid for cooking the matzo balls. In a large, wide saucepan over medium-low heat, bring the water-broth mixture to a bare simmer. Add the remaining 1 teaspoon salt. Carefully slide in the matzo balls and simmer, covered, until cooked through and light in texture, about 20 minutes. (Test one by cutting it in half.)

Meanwhile, peel the carrots and trim the stems, if attached, to 3 inches. After the matzo balls have simmered for about 15 minutes, add the carrots. If necessary, adjust the heat to maintain a simmer after adding the carrots.

In a separate medium saucepan, bring the reserved 8 cups broth to a simmer over medium heat.

Remove the matzo balls from the heat. Place 1 matzo ball and 4 carrots in each soup bowl. (The matzo ball liquid can be strained and reserved for another use.) Ladle approximately ¾ cup of the stock into each bowl and garnish with the remaining 2½ teaspoons dill and the toasted farfel. Serve immediately.

SUMMER CORN SOUP

Serves 6

BG likes to support local purveyors, so when Long Island corn is in season, this means a ready supply of sweet, plump kernels. Flavored with bacon and enriched with heavy cream, this soup is decadent without being heavy. The delicate corn flavor shines through, and against its golden color, any combination of vibrant green herbs, scarlet tomatoes, and lump crab makes the perfect colorful summer garnish.

2 tablespoons grapeseed oil
½ medium yellow onion, diced
1 large carrot, diced
2 celery stalks, diced
2 slices of bacon, diced
2 garlic cloves, minced
¼ cup dry white wine
4 cups fresh or frozen, thawed
 corn kernels
1 cup heavy cream
Salt and freshly ground black pepper
Chopped fresh herbs, such as tarragon,
 chives, and parsley (optional)
Diced tomato (optional)
Lump crabmeat (optional)

Heat the oil over medium heat in a Dutch oven or a large pot with a lid and add the onion, carrot, celery, and bacon. Cook until the vegetables have softened and the fat has been rendered from the bacon, 10 to 15 minutes. Add the garlic and cook, stirring, for 30 seconds.

Pour in the wine, scraping up any brown bits from the bottom of the pan, and reduce until dry. Stir in the corn. Add 4½ cups water and bring to a boil. Reduce the heat to a simmer and cook, covered, until soft, about 25 minutes.

Working in batches, if necessary, purée in a blender or food processor until smooth.

Return the soup to the heat and add the cream. Season with salt and pepper. Serve garnished with any desired combination of herbs, tomato, and/or crabmeat.

TORTILLA SOUP

LELA ROSE, DESIGNER

Serves 8 to 10

This soup, adapted from one served at the Mansion on Turtle Creek Hotel in Dallas, connects Lela to her Texas roots. "When I was young, eating at the Mansion was the height of luxury and decadence," she says. "The chef at that time, Dean Fearing, would present this and all its fixin's with great fanfare." The designer, known for her flair in the kitchen as well as for creating streamlined silhouettes with delicate embellishments, continues to serve it just that way.

3 tablespoons corn oil

5 corn tortillas, coarsely chopped

3 garlic cloves, finely chopped

1 tablespoon chopped fresh epazote or cilantro

1 cup diced yellow onion, puréed in a food processor

3 large tomatoes, puréed in a food processor

1 tablespoon ground cumin

2 teaspoons chili powder

2 bay leaves

2 whole dried pasilla chiles, seeded, or 1 dried ancho chile, seeded

¼ cup canned tomato purée

2 quarts chicken stock

Salt

Cayenne

1 cooked chicken breast, cut into strips

1 ripe avocado, peeled, pitted, and cubed

1 cup shredded cheddar cheese

7 corn tortillas, cut into thin strips and fried crisp

Red pepper flakes

Heat the oil in a large saucepan over medium heat. Sauté the chopped tortillas with the garlic and epazote over medium heat until soft. Stir in the onion and fresh tomato purée and bring to a boil. Add the cumin, chili powder, bay leaves, chiles, canned tomato purée, and stock. Return to a boil, then reduce the heat to simmer. Season to taste with salt and cayenne pepper and cook, stirring frequently, for 30 minutes. Skim the fat from the surface, if necessary.

Strain and pour into warm soup bowls. Garnish with an equal portion of chicken strips, avocado, cheese, and crisp tortilla strips, and finish with a tiny pinch of red pepper flakes. Serve immediately.

TOMATO-FENNEL SOUP

Serves 8

The intensity of flavor in this tomato soup belies how easy it is to whip up. The simple step of roasting the tomatoes, whether fresh or canned, concentrates their sweetness. For a sophisticated update on a familiar and cozy lunch, serve this excellent soup accompanied by BG's Truffled Grilled Cheese Sandwich Bites (page 46).

12 fresh or canned plum tomatoes, halved
¼ cup extra-virgin olive oil
Salt and freshly ground black pepper
1 medium onion, sliced
2 garlic cloves, smashed
1 carrot, diced
2 celery stalks, diced
2 fennel bulbs, root and stalk trimmed, sliced
2 tablespoons tomato paste
¼ cup dry white wine

Place a rack in the middle of the oven and preheat to 400°F.

Place the tomatoes, sliced side up, close together on a baking sheet. Drizzle with ⅛ cup of the oil and season with salt and pepper. Roast in the oven for 45 minutes.

In a large pot over medium heat, warm the remaining ⅛ cup oil and sauté the onion, garlic, carrot, celery, and fennel until soft. Add the tomato paste, roasted tomatoes, wine, and 6 cups water. Simmer gently for 45 minutes. Purée in a blender or food processor and season to taste with salt and pepper. Serve warm.

HEIRLOOM GAZPACHO

Serves 6

BG always takes advantage of fresh, seasonal produce, and this vibrant vegetable soup celebrates summer's bounty. A lighter take on the traditional Spanish version that is usually thickened with bread, this soup is best served well chilled. Diced watermelon is another option for a garnish, and the luscious addition of fresh crab or lobster makes it a bit more substantial.

2 pounds very ripe heirloom tomatoes, chopped

1 red bell pepper, cored, seeded, and chopped

1 green bell pepper, cored, seeded, and chopped

1 cucumber, peeled, seeded, and chopped

2 celery stalks, chopped

2 garlic cloves, smashed

¼ cup olive oil

⅓ cup sherry vinegar

2 tablespoons fresh lemon juice

Salt and freshly ground black pepper

1 cup peeled and diced cucumber

1 cup diced golden tomato

Combine the heirloom tomatoes, red and green bell peppers, cucumber, celery, garlic, oil, vinegar, lemon juice, and salt and pepper to taste in a blender and purée to either a chunky or smooth texture, as desired. Chill in the refrigerator for at least 30 minutes to allow the raw garlic to mellow and the flavors to blend. Garnish with the diced cucumber and golden tomato.

4

Salads

B ack when it was being enjoyed by the ancient Romans, *salad*—from *herba salata*, literally "salted herb"—referred to wild greens pickled in vinegar or salt. Gradually, this evolved into a straightforward dish of fresh greens tossed with a light dressing. Hippocrates believed that raw vegetables did not tax the digestive system and should therefore be served first; others claimed that the vinegar in the dressing dulled the palate and so should be served last. This debate remains unresolved to this day, with salads appearing at both ends of the meal, sometimes accompanying the main course or even replacing it altogether.

From its simple origins, the salad became increasingly complicated, making way for the meat-laden concoctions known in seventeenth-century England as "salmagundi," precursors to today's chef's salad. Composed salads came

next, artful assemblies of judiciously selected and prepared ingredients that reflected a trend toward more orderly presentations, which culminated in the utterly immobile jellied aspic. By the twentieth century, top restaurants had come to pride themselves on creating their own unique and branded salad combinations, such as the classic Waldorf, invented at the hotel of the same name, and the Cobb, a tribute to the owner of the Hollywood Brown Derby.

Of course BG has its own original salad, the wildly popular Gotham, just one in an extensive repertoire that ranges from largely raw and vegetable-focused to more elaborate vehicles for poached seafood, roasted vegetables, or tender slices of steak. What they all share is a reverence for pristine ingredients and a crisp freshness that begs to be enjoyed right away. After all, as Alice Waters said, "It's the immediacy that makes a salad so compelling and seductive."

THE GOTHAM SALAD

Serves 4 to 6

The Gotham Salad is a BG legend. Devised more than thirty years ago as a fresh take on the classic chopped salad, its popularity knows no limits, with more than 2,500 flying out of the BG kitchen every month. Entire shopping excursions are planned around a lunch of this one dish, and there are even customers who have it delivered to their offices daily. Like a favorite wardrobe staple, the Gotham never goes out of style.

8 ounces poached chicken breast, diced to ½-inch cubes

8 ounces red beets, roasted, peeled, and diced to ½-inch cubes

8 ounces Gruyère cheese, diced to ½-inch cubes

4 ounces ham, diced to ½-inch cubes

4 ounces Roma tomatoes, diced to ½-inch cubes

4 hard-boiled eggs, diced to ½-inch cubes

10–12 slices cooked bacon, crumbled into ½-inch-long bits

8 cups finely shredded iceberg lettuce

1 cup Thousand Island Dressing, or to taste (recipe follows)

THOUSAND ISLAND DRESSING

1 tablespoon diced red onion

2 tablespoons diced green bell pepper

¼ cup plus 1 tablespoon chili sauce

2 tablespoons sweet pickle relish

1 tablespoon tarragon vinegar

½ teaspoon minced garlic

½ teaspoon grated peeled fresh ginger

1 cup best-quality mayonnaise

¼ teaspoon salt

Freshly ground black pepper

In a large bowl, combine the chicken, beets, Gruyère, ham, tomatoes, eggs, bacon, and lettuce and toss with the dressing.

TO MAKE THE THOUSAND ISLAND DRESSING: In a food processor or blender, purée the onion, bell pepper, chili sauce, relish, vinegar, garlic, and ginger.

Add the mayonnaise and blend well. Season with salt and pepper.

ASIAN CHICKEN SALAD

Serves 4

This delicious, crunchy salad relies on a few authentic Asian ingredients that are worth tracking down at a specialty or gourmet market. Tatsoi, also called spinach mustard, is a crisp green vegetable with a bold flavor. The bonito flakes in the dressing are delicate shavings made from dried, smoked fish that add a powerful hit of umami perfectly balanced by mirin, a sweet rice wine. The delightful Candied Cashews are an original BG addition.

4 cups poached, shredded chicken breast
4 cups shredded napa cabbage
Small bunch of tatsoi, chopped (2–3 cups)
½ pound snow peas, julienned
½ green bell pepper, cored, seeded, and julienned
½ red bell pepper, cored, seeded, and julienned
¾ cup Asian Dressing (recipe follows)
1 cup Candied Cashews (recipe follows)

ASIAN DRESSING
3 tablespoons mirin
¼ cup rice vinegar
1 tablespoon soy sauce
2 tablespoons bonito flakes
¼ cup lime juice, or to taste
1 teaspoon grated ginger
Pinch of sugar
Pinch of wasabi powder

CANDIED CASHEWS
1 cup raw cashews
6 tablespoons sugar
Pinch of salt

In a large bowl, toss together the chicken, cabbage, tatsoi, snow peas, green bell pepper, and red bell pepper with the dressing, then divide among 4 plates. Sprinkle a scant ¼ cup of candied cashews on top of each serving.

TO MAKE THE ASIAN DRESSING:
In a small bowl, whisk together all the ingredients until well combined.

TO MAKE THE CANDIED CASHEWS:
Place a rack in the middle of the oven and preheat to 350°F.

Line a baking sheet with parchment paper. Spread the cashews on the baking sheet and toast until fragrant and light golden brown, 6 to 8 minutes.

In a large skillet, combine the sugar and salt with 2 tablespoons water. Simmer without stirring, swirling occasionally, until the liquid is a light amber, 10 to 12 minutes. Remove from the heat and immediately stir in the toasted nuts. Lift the nuts out of the skillet with a slotted spoon and spread them out on the baking sheet to cool. Use your hands to gently break up any large clusters.

ROASTED CHICKEN AND FREGOLA SALAD

Serves 4

This well-balanced dish is a more unusual alternative to the classic pasta salad and makes a hearty lunch in any season. Fregola, a Sardinian semolina pasta shaped like couscous, adds texture and a lemon-spiked vinaigrette keeps things bright. Toast the pine nuts for the garnish in a small skillet over a low flame, keeping a close watch to prevent them from burning.

12 ounces cooked fregola or Israeli pearl couscous
1 pound roasted chicken breast, shredded
10 ounces grape tomatoes
1 10-ounce jar roasted red peppers
4 cups (packed) baby arugula
1 4-ounce jar grilled artichoke hearts
½ cup Lemon Vinaigrette, plus more for serving (recipe follows)
2 teaspoons pine nuts, lightly toasted
Salt and freshly ground black pepper

LEMON VINAIGRETTE
2 tablespoons fresh lemon juice
2 tablespoons Dijon mustard
2 tablespoons honey
2½ cups grapeseed oil

In a large bowl, combine the fregola, chicken, tomatoes, red peppers, arugula, and artichokes. Toss with the vinaigrette, then top with the pine nuts. Serve chilled or at room temperature, along with a side of extra vinaigrette.

TO MAKE THE LEMON VINAIGRETTE: In a small bowl, stir together the lemon juice, 2 tablespoons water, the mustard, and the honey, then gradually whisk in the oil until emulsified. Leftover dressing can be covered tightly and stored in the refrigerator for 3 to 5 days.

THE CANNON SALAD

STACY LONDON, STYLE EXPERT AND TELEVISION PERSONALITY

Serves 4 to 6

An authority on what to wear and what not to, Stacy is also quite interested in food that is both delicious and healthy. During a weekend with friends—among them former BG social media maven Cannon Hodge—she came up with this inventive salad that includes bitter greens and guacamole. According to Stacy, "Cannon loved this salad so much, I named it after her. If it becomes more popular than the Cobb, we can fight over royalties later."

1 pound roasted chicken or turkey, cut into bite-size chunks (about 2½ cups)

4 ounces (1 cup) feta cheese, crumbled

4 ounces (⅔ cup) unsalted cashews, roasted and roughly chopped

3 jalapeños, finely chopped (seeded first, if less heat is desired)

Bunch of dandelion greens, thinly sliced

Bunch of kale, thinly sliced

½ cup Guacamole (recipe follows)

Dressing (recipe follows)

GUACAMOLE

3 ripe avocados, pitted and peeled

2 tablespoons minced fresh cilantro

1 tablespoon minced white onion

2 garlic cloves, minced

Juice of 1 lime

1 tablespoon sour cream

1 tablespoon hot sauce

Salt

DRESSING

1½ ounces extra-virgin olive oil

1½ ounces red wine or apple cider vinegar

Salt and freshly ground black pepper

(continued on next page)

In a large salad bowl, assemble the salad by layering the chicken, feta, cashews, jalapeños, dandelion greens, and kale. When ready to serve, add the guacamole and dressing and toss well. (The salad, guacamole, and dressing can be refrigerated in separate airtight containers until ready to serve.)

TO MAKE THE GUACAMOLE: In a large bowl, lightly mash the avocados, then stir in the cilantro, onion, garlic, lime juice, sour cream, and hot sauce. Season to taste with salt.

TO MAKE THE DRESSING: Whisk together the oil and vinegar. Season to taste with salt and pepper.

STEAK SALAD

Serves 4

With plenty of vegetables and a creamy crumble of blue cheese, this fortifying steak salad fits the bill for almost every appetite. The anchovies hidden in the wonderful garlic dressing are the secret to its rich savoriness.

1 pound mixed salad greens
1 8-ounce jar marinated artichoke hearts
20 ounces grape tomatoes, halved
2½ ounces radishes, very thinly sliced
2½ ounces fennel, very thinly sliced
4 ounces blue cheese, crumbled
½–¾ cup Creamy Garlic Dressing
 (recipe follows)
4 ounces medium-rare filet mignon,
 thinly sliced

CREAMY GARLIC DRESSING
1 garlic clove, crushed
2 anchovies
1 tablespoon Dijon mustard
1 large egg yolk
Sprig of thyme
Sprig of rosemary
¼ cup spinach
8 fresh basil leaves
¾ cup olive oil
Salt and freshly ground black pepper

In a large bowl, combine the salad greens, artichokes, tomatoes, radishes, fennel, and blue cheese, then toss with enough dressing to lightly coat. To serve, mound the salad in the center of 4 plates, then layer a portion of filet mignon on top. Drizzle the top with a little extra dressing.

TO MAKE THE CREAMY GARLIC DRESSING: Combine ⅛ cup water, the garlic, anchovies, mustard, egg yolk, thyme, rosemary, spinach, and basil in a blender or food processor and purée until smooth. With the machine still running, slowly drizzle in the oil until fully incorporated. Season to taste with salt and pepper.

LOBSTER SALAD

Serves 4

With plentiful chunks of lobster and avocado, this satisfying salad, part of BG's healthy menu, still manages to come in at fewer than 500 calories. That fact and its great taste make it a perennial favorite.

2 small ripe avocados, peeled, pitted, and diced
½ cup diced celery
¼ cup diced red onion, sautéed in
1 teaspoon olive oil
2 cups grape tomatoes, halved
5 tablespoons Champagne Vinaigrette (recipe follows)
18 ounces cooked fresh lobster meat
Salt and freshly ground black pepper
4 cups mixed baby lettuces

CHAMPAGNE VINAIGRETTE
2 tablespoons Champagne vinegar
2 tablespoons Dijon mustard
2 tablespoons honey
½ cup grapeseed oil
Salt and freshly ground black pepper

In a large bowl, combine the avocados, celery, onion, and tomatoes and toss with 2 tablespoons of the vinaigrette. Set aside.

In a separate medium bowl, toss the lobster with 2 tablespoons of the vinaigrette. Season to taste with salt and pepper.

In a third large bowl, toss the lettuces with 1 tablespoon of the vinaigrette.

To assemble each serving of the salad, place a quarter of the avocado mixture in the base of a 4-inch ring mold. Top with a quarter of the lobster salad and add 1 cup of the lettuces. Remove the ring mold and serve.

TO MAKE THE CHAMPAGNE VINAIGRETTE: In a blender, combine the vinegar, mustard, honey, oil, and ¼ cup water and process until smooth. Season to taste with salt and pepper.

SOFT-SHELL CRAB SALAD

Serves 6

A seasonal delicacy that can be eaten whole, soft-shell crabs are available from spring through late summer. Lacking a true shell of their own, these get a crunchy coating from a light batter that is fried to a golden crisp. The trick to a greaseless presentation is to have the oil very hot. If you don't have a deep-fat thermometer, try inserting a chopstick perpendicularly into the oil; when a brisk line of bubbles streams off the side, the oil is hot enough for frying.

Vegetable oil, for frying
1 large egg
½ cup whole milk
½ cup all-purpose flour
1 teaspoon baking powder
Pinch of salt
6 soft-shell crabs, cleaned
4 cups mixed salad greens
Garlic Aioli (recipe follows)

GARLIC AIOLI
1 garlic clove, minced and mashed
 into a paste
1 large egg, at room temperature
1 tablespoon fresh lemon juice
1 tablespoon chopped fresh parsley
½ teaspoon salt
Freshly ground black pepper
½ cup olive oil

Fill a wide saucepan or large, deep skillet with ½ inch of oil and heat to 360°F.

In a medium shallow bowl, beat together the egg and milk. In a separate small bowl, combine the flour, baking powder, and salt.

Coat the crabs one at a time, first in the egg mixture, then in the flour mixture. Cook in hot oil until golden brown, turning once. Drain on paper towels for 5 minutes.

To serve, divide the salad greens among 6 plates and arrange a crab on each one, with a dollop of aioli on the side.

TO MAKE THE GARLIC AIOLI:
Combine the garlic, egg, lemon juice, parsley, salt, and pepper to taste in a food processor or blender and purée. With the machine still running, add the oil in a slow, thin stream to form a thick emulsion.

CRAB QUINOA

DIANE VON FURSTENBERG, DESIGNER

Serves 6 to 8

Every two years, Diane travels to Venice to attend the Biennale. "When I think of Venice I think of art," she says. "I also think of drinking a Bellini on the terrace of the Gritti Palace and, of course, of the incredible seafood. Here is a great little recipe from my chef, Jane Coxwell." This crab and quinoa salad spiked with horseradish is a tribute to the City of Bridges and its renowned lagoon brimming with delicacies.

2 heaping cups quinoa

6 ounces cherry tomatoes

¼ red onion, finely chopped

2 garlic cloves, minced

4 teaspoons horseradish

1½ pounds lump crabmeat, carefully picked through for shells

¼ cup best-quality mayonnaise

½ teaspoon agave nectar, or to taste

Juice of 1 lemon, plus more as needed

Tabasco sauce

Maldon sea salt and freshly ground black pepper

Handful of fresh Italian parsley, roughly chopped

Handful of fresh cilantro, roughly chopped

Handful of fresh dill, roughly chopped

Rinse the quinoa thoroughly in cold water and cook in a medium saucepan according to the package directions. Drain, then return to the hot pan. Cook over low heat, stirring to release any excess water.

Transfer the warm quinoa to a large bowl and add the tomatoes, onion, garlic, horseradish, crabmeat, mayonnaise, agave nectar, lemon juice, and Tabasco to taste. Season with salt and pepper. Set aside to cool to room temperature or cover and place in the refrigerator. When ready to serve, add the herbs. Taste for seasoning, and if desired, add more lemon, Tabasco, agave nectar, and/or salt and pepper.

QUINOA NADIA

ROBERT VERDI, STYLIST

Serves 6 to 8

The son of a French chef, Robert was exposed to the joys of spontaneous cooking from an early age. This recipe was the result of equal parts creativity and serendipity. "The night I invented this, my fridge happened to be chock-full of all my favorite things," he remembers. "Now I make a big pot every Sunday to eat throughout the week, often changing the mix depending on what's around." It's a dish that's ripe for improvisation.

1½ cups chopped white and cremini mushrooms
¼ cup olive oil
1 medium white onion, chopped
3 garlic cloves, finely chopped
2 cups quinoa
1 pint cherry tomatoes, quartered
2 medium ripe avocados, pitted, peeled, and diced
¾ cup Moroccan black olives, pitted and chopped
¾ cup almonds, toasted and chopped
¾ cup dried cranberries
Salt and freshly ground black pepper

In a medium saucepan, sauté the mushrooms with 2 teaspoons of the oil until golden brown. Set aside.

In a large stockpot over medium heat, warm the remaining oil and sauté the onion and garlic until soft and translucent, about 10 minutes. Add the quinoa and sauté for another 2 minutes. (The quinoa will stick to the onions.)

Add 5 cups water and bring to a boil. Reduce the heat and simmer, stirring frequently until the water reduces, about 8 minutes. Mix in the sautéed mushrooms and continue stirring, another 5 to 7 minutes. Remove from the heat and cool slightly. Add the tomatoes, avocados, olives, almonds, and cranberries. Season to taste with salt and pepper. Serve warm, or chill and serve cold.

LOBSTER AND CRABMEAT SALAD

Serves 4

No seafood lover can resist this jumble of fresh lobster and crab over a pile of tender greens, especially tossed in BG's creamy and spicy Brandy Chive Dressing. That this dish is molded into a tall cylinder and served on a plate drizzled with vivid green chive oil further heightens its appeal.

10 ounces fresh lobster claw and knuckle meat, diced
10 ounces jumbo lump crabmeat, carefully picked through for shells and diced
2 avocados, pitted, peeled, and finely diced
2 Roma tomatoes, finely diced, plus extra for garnish
4 cups chopped frisée
Brandy Chive Dressing (recipe follows)
Salt and freshly ground black pepper
Chive Oil (recipe follows)
2 tablespoons minced fresh chives

BRANDY CHIVE DRESSING
1 cup best-quality mayonnaise
¼ cup chili sauce
2 tablespoons balsamic vinegar
1 tablespoon brandy
¼ cup minced fresh chives
¾ teaspoon minced garlic
¾ teaspoon minced peeled fresh ginger
½ teaspoon salt
½ teaspoon freshly ground black pepper

CHIVE OIL
¼ cup olive oil
2 tablespoons chopped fresh chives
Salt and freshly ground black pepper

In a large bowl, combine the lobster, crab, avocados, tomatoes, and frisée. Toss with enough dressing to lightly coat. Season with salt and pepper.

To assemble a serving, place a 4-inch ring mold in the center of a salad plate and pack a quarter of the salad mixture into the mold. Drizzle the salad surface with chive oil and decorate the plate with a few drops. Garnish with minced chives and additional diced tomato. Remove mold and serve.

TO MAKE THE BRANDY CHIVE DRESSING: Combine all the ingredients in a blender and purée until smooth.

TO MAKE THE CHIVE OIL: Combine the olive oil and chives in a mini-processor and purée, or grind together using a mortar and pestle. Season to taste with salt and pepper.

CURED AND SEARED SALMON SALAD

Serves 4

Essentially a gravlax that is removed from its aromatic cure after just a few hours, the salmon in this dish finishes cooking on the stove. It has a mild, sweet flavor and a velvety texture that is nicely complemented by the crunchy apple and celeriac salad. At BG, it's often served with daikon rolls stuffed with mango, cucumber, avocado, and fresh mint.

4 skin-on salmon fillets (4 ounces each)
Curing Mix (recipe follows)
1 Granny Smith apple, cored and diced
½ medium celeriac, peeled and very
 thinly sliced
Large handful of baby greens
Miso Vinaigrette (recipe follows)

CURING MIX
¼ cup salt
2 cups (packed) light brown sugar
¾ cup vodka
1 tablespoon mustard seeds
1 tablespoon fennel seeds
1 tablespoon coriander seeds
Bunch of dill, roughly chopped

MISO VINAIGRETTE
½ cup soy sauce
¼ cup Dijon mustard
½ cup white miso
¼ cup honey
¾ cup water

Place salmon fillets in a glass dish and thoroughly coat with the curing mix. Cover with plastic wrap and refrigerate for 2 to 4 hours.

Remove the salmon from the refrigerator, and using a paper towel, wipe off the excess curing mix and discard it.

In a large skillet over medium heat, sear the salmon and cook until medium rare, about 3 minutes per side. Allow the salmon to cool, then transfer to a plate, cover, and chill.

When ready to serve, toss the apple, celeriac, and salad greens with enough vinaigrette to lightly coat. Mound the salad on plates and arrange a salmon fillet on top. As an option, the salmon may also be sliced and fanned out on top of the greens.

TO MAKE THE CURING MIX: In a medium bowl, stir together the salt, sugar, vodka, mustard seeds, fennel seeds, coriander seeds, dill, and ½ cup water until well combined.

TO MAKE THE MISO VINAIGRETTE: In a small bowl, whisk all the ingredients together until fully combined.

HARVEST SALAD

Serves 4

A perennial BG favorite, this salad is popular throughout the year. The red apple and cranberries enliven the dish with color, while the blue cheese and toasted pecans give it a big boost in flavor. The poppy seed dressing adds a delightfully nutty crunch.

14 ounces roast chicken breast, chopped
4 cups chopped crisp romaine lettuce
1 red apple, cored and diced
½ cup Poppy Seed Vinaigrette (recipe follows)
4 ounces blue cheese, crumbled
½ cup pecans, toasted
½ cup dried cranberries

POPPY SEED VINAIGRETTE
1 tablespoon Dijon white wine mustard
2 tablespoons Champagne vinegar
1 tablespoon diced shallot
1 tablespoon poppy seeds
¼ cup olive oil
¼ cup vegetable oil

In a large salad bowl, layer the chicken, romaine, and apple. Toss them with the vinaigrette and top with the blue cheese, pecans, and cranberries.

TO MAKE THE POPPY SEED VINAIGRETTE: Combine the mustard, vinegar, shallot, and poppy seeds in a container. Slowly whisk in the oils to form an emulsion. Extra dressing will keep in the refrigerator for 3 to 5 days.

DELICIOUS BEETS
AND THEIR GREENS

PATRICIA FIELD, STYLIST AND DESIGNER

Serves 4

Perhaps best known for her Emmy Award–winning work on *Sex and the City*, Patricia has been a fashion pioneer since she opened her Greenwich Village boutique in 1966. The shop's current location on the Bowery, the site of her former apartment, was once the setting for her monthly dinner parties, where she often served this dish. "I love to convert beet haters to beet lovers," she says. "This recipe does it every time."

Bunch of beets, including greens
Salt
1 small red onion, thinly sliced
Handful of fresh parsley, chopped
Handful of fresh dill, chopped
½–¾ cup extra-virgin olive oil
Balsamic or red wine vinegar or
 fresh lemon juice
Freshly ground black pepper

Wash and drain the beets. Cut the greens off the beets and set them aside.

In a large stockpot, bring 2 to 3 quarts salted water to a boil and cook the beets until tender, 30 to 40 minutes. Remove the beets with a slotted spoon. Let cool, then peel.

Pour out most of the boiling water, leaving about 2 inches in the pot. Place a steamer inside the pot and arrange the greens on top. Lightly salt them. Steam, covered, until tender but still a bit crunchy, 8 to 10 minutes.

Place the greens on a platter or serving dish. Slice the cooled beets and arrange them on top. Garnish with the onion slices, parsley, and dill. Pour oil evenly over the beets and greens, then drizzle them with vinegar for a subtle flavor accent. Season to taste with salt and pepper.

ROASTED BEET
AND CARROT SALAD

Serves 4

A vegetarian's dream—and equally irresistible to most omnivores. The few extra steps required for this composed salad deliver a delicious reward. Carrots are slathered in a spiced marinade, then roasted alongside earthy beets until tender and caramelized. The vegetables are arranged on a bed of arugula tossed with a horseradish dressing and showered with a sweet-salty sunflower brittle.

1 tablespoon ground cumin
1 tablespoon ground coriander
1 tablespoon ground cinnamon
2 tablespoons minced garlic
2 tablespoons fresh lemon juice
1 tablespoon apple cider vinegar
1 cup grapeseed oil
8 baby carrots, with 1-inch stems
 attached, if possible
2 large beets
Large bunch of baby arugula
Horseradish Vinaigrette (recipe follows)
2 ripe avocados, pitted, peeled, and
 sliced into wedges
¼ cup crumbled feta cheese
Sunflower Brittle (recipe follows)

HORSERADISH VINAIGRETTE
½ cup finely grated fresh horseradish
1 tablespoon minced garlic
3 tablespoons honey
3 tablespoons Dijon mustard
½ cup rice wine vinegar
1 cup grapeseed oil

SUNFLOWER BRITTLE
1 cup sugar
½ cup light corn syrup
1½ tablespoons unsalted butter
1 teaspoon salt
½ teaspoon baking soda
1 cup raw sunflower seeds

In a small skillet over medium-low heat, toast the cumin, coriander, and cinnamon until fragrant. Whisk them together with the garlic, lemon juice, vinegar, and oil to make a marinade.

Place a rack in the middle of the oven and preheat to 400°F.

In a large, shallow bowl, slather the carrots with marinade and allow the flavors to meld at room temperature for an hour. Line a baking sheet with parchment paper. Peel and dice the beets and spread them on half of the baking sheet.

After 1 hour, remove the carrots from the marinade and spread them on the other half of the baking sheet. Roast the vegetables in the oven for 40 to 50 minutes, or until tender.

To assemble the salad, lightly toss the arugula with enough vinaigrette to lightly coat. Toss the carrots and beets with a little vinaigrette and arrange them on top of the greens along with the avocado wedges. Sprinkle the feta cheese over the greens and garnish with shards of sunflower brittle.

TO MAKE THE HORSERADISH VINAIGRETTE: In a small bowl, whisk together the horseradish, garlic, honey, mustard, vinegar, oil, and 1 cup water until emulsified.

TO MAKE THE SUNFLOWER BRITTLE: Line a baking sheet with parchment and set aside. Mix together the sugar, ½ cup water, and the corn syrup in a medium saucepan and cook on medium-high heat until the sugar dissolves and the syrup turns a light golden brown. Remove the pan from the heat and immediately stir in the butter, salt, baking soda, and sunflower seeds. Pour onto the baking sheet and, with a spatula, spread out into a thin sheet. Cool until it hardens, then crack into bite-size pieces. Store any extra at room temperature in an airtight container. The brittle will keep for 3 days.

SUMMER TOMATO, PEACH, AND **BASIL SALAD**

ATHENA CALDERONE, INTERIOR DESIGNER AND
CREATOR OF EYE-SWOON.COM

Serves 4

On her popular blog, Athena shares her lifestyle, full of exotic locations, beautifully decorated spaces, and gorgeous, fresh food. "Finding a way to marry contrasting elements is at the heart of my creative passion," she says. "So I had fun combining my two favorite elements of summer's bounty: baby heirloom tomatoes and sweet juicy peaches." You'll want to serve this inspired dish all summer long.

1 pint mixed baby heirloom tomatoes, halved
1 ripe peach or nectarine, halved and diced
½ red onion, thinly sliced
1 small garlic clove, minced
Maldon sea salt and freshly ground black pepper
¼ cup extra-virgin olive oil
Splash of red wine vinegar
Zest and juice of 1 lemon
5–7 fresh basil leaves

In a large bowl, combine the tomatoes, peach, onion, and garlic. Season with salt and pepper to taste. Mix in the oil, vinegar, and lemon zest and juice. Let the mixture rest for a half hour or so at room temperature so the flavors can meld.

When ready to serve, gently tear the basil leaves and add to the salad. Check the seasoning and adjust as needed.

ARUGULA, PERSIMMON, AND POMEGRANATE SALAD

KELLY WEARSTLER, INTERIOR DESIGNER

Serves 4

A highly accomplished designer based on the West Coast, Kelly is responsible for the BG restaurant's deluxe decor. "Every holiday season, I visit the local farmers' market with my boys to get the fresh, seasonal ingredients for this favorite salad," she says. "Crimson pomegranate and green arugula make the dish not only delicious but full of beautiful, festive color."

1 tablespoon sherry vinegar
3 tablespoons extra-virgin olive oil
4 handfuls of arugula
2–3 fuyu persimmons, trimmed, peeled, and cut into chunks or small wedges
½ cup pomegranate seeds
Salt and freshly ground black pepper
Parmesan cheese shavings

Whisk together the vinegar and oil. Toss with the arugula, persimmons, and pomegranate seeds. Season to taste with salt and pepper. Garnish with Parmesan cheese shavings.

5

Entrées

The entrée was born at a time when meals were composed of one elaborate course after another. In seventeenth-century France, *entrée* referred to the hot meat course, not to be confused with the roast course that followed. Fortunately, dining is simpler today, and the entrée has found its place as the focal point of the meal. Whether bracketed by a starter and dessert or served as a sole offering, it's generally regarded as the main event. Perhaps that's why the entrée is where most people concentrate their efforts. Since it commands the spotlight, it's arguably the best place to spend the time and energy needed to make something truly memorable.

Many such dishes grace the BG menu, in part because the restaurant hosts so many special occasions and celebratory dinners. While the glorious Lobster Napoleon—a

luscious combination of shellfish, chanterelles, and fresh pasta—may not be the stuff of everyday meals, there are plenty of lighter but equally refined dishes, such as the Roasted Salmon Salad or the baked Chicken Milanese, that definitely are. BG also pays attention to evolving culinary trends, especially those that promise to have a lasting impact, including the vegetable-focused cuisine that has emerged from the farm-to-table movement. Cauliflower Steaks with Sauce Gribiche is an inspired response that appeals to vegans, vegetarians, and omnivores alike.

The best meals are often those enjoyed with others, regardless of the culinary heights you scale in making them. If you offer nothing more than a well-prepared entrée, a graciously laid table, and pleasant company, the evening will surely be a success.

LOBSTER NAPOLEON

Serves 6

This recipe presents a savory twist on the classic napoleon, a sweet French confection made with alternating layers of cream and pastry. Neither one has anything to do with the emperor of the same name, but both are worthy of royalty. In BG's version, chunks of lobster meat and chanterelles bound in a rich sauce are layered with sheets of fresh pasta for a truly spectacular dish that will impress guests.

4 live lobsters (1½ pounds each)
¼ cup plus 1 tablespoon olive oil
½ Spanish onion, roughly chopped
1 carrot, roughly chopped
2 celery stalks, roughly chopped
¼ cup tomato paste

2 cups heavy cream
1 cup diced chanterelle mushrooms
12 sheets fresh egg pasta, cut into
 4-inch squares
Salt
Freshly shaved black truffle

Bring a large stockpot of water to a boil. Add the lobsters, headfirst, and boil for 8 minutes. Using tongs, transfer the cooked lobsters to a large bowl. When cool enough to handle, twist off the lobster tails and claws, working over a large bowl or sink. Crack the shells on the tail and claws. Remove and dice the lobster meat and set the meat aside. Coarsely chop the lobster shells and bodies, discarding the head sacs and any roe, and transfer to a large bowl.

Warm ¼ cup of the oil in a large pot over medium-high heat, then add the onion, carrot, celery, and as many of the lobster shells and bodies as can fit comfortably (about 3 full lobsters). Sauté until brown, stirring often, about 10 to 15 minutes.

Add 2½ quarts water and whisk in the tomato paste. Bring to a boil, then reduce the heat to low and simmer until reduced by half, 30 to 45 minutes. Strain, discarding the solids.

Return the sauce to the pot and stir in the heavy cream. Cook on medium heat until thickened, 10 to 15 minutes. (If you prefer not to make your own sauce, substitute 5 cups best-quality lobster bisque.)

Meanwhile, prepare the chanterelles. In a small pan over medium heat, warm the remaining 1 tablespoon oil, add the chanterelles and a pinch of salt, and cook until soft, 4 to 5 minutes.

Add the lobster sauce and chanterelles to the bowl of lobster meat and mix well.

Bring a large stockpot filled with salted water to a boil and blanch the pasta sheets for 2 minutes. Drain well.

To assemble the napoleons, place 1 sheet of pasta on each of 6 plates. Cover with a scoop of the lobster mixture, then a second sheet of pasta, and spoon additional lobster on top.

Garnish with truffle shavings and serve.

PAN–SEARED BLACK BASS
WITH FRESH HERB PISTOU

Serves 6

Ideal for a quick lunch, this simple dish is also elegant enough to serve at a party; in fact, the recipe was developed for a BG dinner with designer Reed Krakoff. The pistou, a vibrant purée of fresh herbs and olive oil, is wonderful with the fish, but its bold flavors also stand up to roast chicken, pork chops, and grilled steak.

1¼ cups fresh Italian parsley leaves

1 cup fresh chervil

¾ cup fresh tarragon, thick stems removed

½ garlic clove

¾ cup ice water

2 tablespoons extra-virgin olive oil

Kosher salt

2 tablespoons vegetable oil

6 skin-on black bass fillets (5 ounces each)

Freshly ground black pepper

Fill a large pot with salted water and bring to a boil. Blanch the herbs for 10 seconds, then remove with a slotted spoon and plunge in a medium bowl of ice water. Allow to cool completely, then drain, squeeze dry, and roughly chop.

Purée the herbs, garlic, and ¾ cup ice water in a blender until smooth, about 3 minutes. With the machine running, gradually add the olive oil in a steady stream to form an emulsion. Season with salt and set aside.

Warm 1 tablespoon of the vegetable oil over medium-high heat in each of 2 large heavy skillets. Season the bass with salt and pepper and add 3 fillets, skin side down, to each skillet. Cook over moderately high heat until the skin is browned and crisp, about 4 minutes. Turn and cook until the flesh is just opaque throughout, about 2 minutes longer.

To serve, plate immediately and top with a generous spoonful of the pistou.

HAW MOK
(FISH STEAMED IN BANANA LEAF)

THAKOON PANICHGUL, DESIGNER, THAKOON

Serves 6

A native of Thailand who was raised in the United States, Thakoon is known for designs that utilize dimension and layering to create a very modern femininity. His recipe for steamed fish consists of cooking the fish in small bowls made from banana leaves that have been pleated—a dressmaker's technique transposed to the kitchen. "Haw mok is our special fish dish for the holidays," he says. "Without it, we are never quite satisfied."

6 banana leaves (found in the freezer section of Asian markets)

1 4-ounce can coconut milk

1 large egg

1 tablespoon red curry paste

½ teaspoon fish sauce

½ teaspoon sugar

2 pounds white fish (cod, tilapia, or red snapper), cleaned, skinned, and cut into 1-inch chunks

5 kaffir lime leaves, thinly sliced

2 Thai red chiles, seeded and thinly sliced

2 handfuls of Thai basil leaves, finely chopped

Cut the banana leaves into six 6-inch rounds. Pleat the edges to form little bowls and secure them with toothpicks. If banana leaves aren't available, use small ramekins instead.

In a medium bowl, blend together the coconut milk, egg, and curry paste. Mix in the fish sauce and sugar. Stir in the fish and divide the mixture equally among the 6 bowls. Arrange the lime leaves, chiles, and basil leaves on top.

Fill a large pot with several inches of water and place a steamer on top. Set the bowls in the steamer, cover, and cook over high heat, steaming for 10 to 12 minutes or until the fish is cooked through. Serve warm, accompanied by steamed rice.

BAKED ATLANTIC COD WITH CELERIAC–APPLE PURÉE AND BRUSSELS SPROUT SALAD

Serves 4

The most intriguing element of this dish is the raw Brussels sprout salad, an innovative slaw that relies on thin shavings of the vegetable enlivened with tart apple and a citrusy dressing. The salad provides just the right textural and flavor contrast to the pristine fish fillet and creamy celeriac purée. Scarlet gems of fresh pomegranate make a brilliant garnish.

BAKED ATLANTIC COD
4 skinless cod fillets (about 5 ounces each)
Olive oil
Salt and freshly ground black pepper
8 tablespoons Celeriac-Apple Purée (recipe follows)
Citrus oil
Brussels Sprout Salad (recipe follows)
4 teaspoons pomegranate seeds
Pomegranate molasses

CELERIAC–APPLE PURÉE
2 cups peeled and diced (1-inch) celeriac
2 medium Granny Smith apples, peeled, cored, and cut into 8 wedges
1 tablespoon olive oil

Salt and freshly ground black pepper
⅔ cup heavy cream
3 tablespoons unsalted butter

BRUSSELS SPROUT SALAD
10 ounces Brussels sprouts, shaved or very thinly sliced
2 medium Granny Smith apples, cored, quartered, and thinly sliced
Fresh chopped herbs, such as basil, chives, and chervil
4 teaspoons citrus oil
4 teaspoons extra-virgin olive oil
2 teaspoons fresh lemon juice
1 teaspoon minced garlic
Salt and freshly ground black pepper

TO MAKE THE BAKED ATLANTIC COD: Place a rack in the middle of the oven and preheat to 400°F.

Brush the cod lightly with olive oil, season with salt and pepper, and bake until the fish is just cooked through, 12 to 15 minutes.

To serve, spread 4 tablespoons purée in a thick line on each plate and set a cod fillet on top. Drizzle the cod with citrus oil, arrange one-quarter of the salad on top of each portion of fish, and sprinkle with 1 teaspoon pomegranate seeds. Drizzle pomegranate molasses around the edges of each plate and serve.

TO MAKE THE CELERIAC-APPLE PURÉE: Place a rack in the middle of the oven and preheat to 425°F.

Place the celeriac in a large saucepan, cover with cold water by 2 inches, and bring to a boil. Cook until nearly fork tender but still slightly firm, about 10 minutes.

Line a baking sheet with parchment paper. When the celeriac is done, drain, place in a bowl with the apples, toss with the oil, and season with salt and pepper. Spread in a single layer on the baking sheet and roast until golden, 15 to 20 minutes.

Meanwhile, warm the cream in a small saucepan over low heat. Remove the celeriac and apples from the oven and place in a blender or food processor. Add the butter and cream, and purée until smooth. Taste and adjust seasoning, as needed. Refrigerate any leftovers in an airtight container for up to 3 days.

TO MAKE THE BRUSSELS SPROUT SALAD: In a large bowl, combine the Brussels sprouts, apples, and herbs. In a small bowl, whisk the remaining ingredients together to make a dressing and toss it with the salad. Allow to sit at room temperature for 30 minutes to let the raw garlic mellow and the flavors meld.

BAKED MASHED POTATOES
with HEMINGWAY TROUT

ANNE SLOWEY, FASHION NEWS DIRECTOR, *ELLE* MAGAZINE

Serves 4

This recipe is Anne's revamp of a dish she had during Fashion Week at Paris's Brasserie Lipp. She makes it with local trout at her weekend home in upstate New York. "To prepare the trout," she says, "I use a variation on a recipe Ernest Hemingway learned while fishing the Irati River in the Basque region of Spain." The ham is optional, and the fish can also be simply steamed in white wine with lemon, butter, and parsley.

2 pounds Yukon Gold potatoes
1 cup half-and-half
1½ tablespoons sour cream
Salt and freshly ground black pepper
4 whole trout (about 1 pound each),
 gutted and cleaned

12 slices Serrano ham
2–3 tablespoons extra-virgin olive oil
Sprig of rosemary
Sprig of marjoram
2 garlic cloves, smashed
3 tablespoons salted butter

Place a rack in the middle of the oven and preheat to 350°F.

Peel half the potatoes and cut these along with the rest into quarters. Put them in a large stockpot and cover with cold water. Bring to a boil and cook until tender, about 20 minutes. Drain well.

Meanwhile, heat the half-and-half in a small saucepan.

Put the potatoes through a ricer and transfer to a large bowl. Mix in the half-and-half and sour cream. Season with salt and pepper. Set aside as you prepare the trout.

Sprinkle the fish cavities with salt and pepper, and layer 2 slices of Serrano ham inside each.

In an ovenproof skillet over medium heat, warm 2 tablespoons oil with the rosemary, marjoram, and 1 of the garlic cloves. Finely chop the remaining ham and add to the skillet. Simmer for

6 to 8 minutes, then transfer the ham to a plate, leaving the herbs and garlic behind.

Add more oil, if necessary, and place the trout in the skillet. Cook in batches, as needed, to avoid crowding the pan. Fry until golden brown on the first side, 5 to 7 minutes. Flip fish and cook another 5 to 7 minutes.

Skin and debone the trout, and dice the ham that was inside. Cut trout into 1½-inch pieces.

Wipe out the skillet and add the mashed potatoes, forming a mound in the center of the pan. Gently nestle the trout and all the ham in the center of the potatoes. Stud all over with slivers of salted butter and thin slices of the remaining garlic clove. Bake for 10 to 15 minutes, until it is warm throughout and the butter is melted. Serve immediately.

GRILLED SHRIMP WITH SHAVED BRUSSELS SPROUTS

Serves 4

This perfectly balanced dish comes together in no time and makes a satisfying lunch or weeknight dinner. The Brussels sprouts are wilted in a pan before being tossed in a light dressing along with sliced apple. The herb oil used to marinate the shrimp is also excellent on grilled bread or drizzled over rice. Make extra and store it in an airtight container in the refrigerator for a few days.

16 large shrimp, cleaned, with tails left on
Herb Oil (recipe follows)
½ cup olive oil
4 cups Brussels sprouts, thinly sliced or shaved with a mandoline
1 garlic clove, minced
1 teaspoon chopped fresh thyme leaves

1 Granny Smith apple
3 tablespoons fresh lemon juice
Salt and freshly ground black pepper

HERB OIL

2 cups roughly chopped mixed fresh parsley, chives, and basil
1 garlic clove, crushed
½ cup extra-virgin olive oil

Marinate the shrimp in the herb oil for 15 minutes.

Place a rack in the top third of the oven and preheat the broiler.

Meanwhile, heat 3 tablespoons of the olive oil in a large skillet and sauté the Brussels sprouts with the garlic and thyme until just wilted, 2 to 3 minutes. Remove from the heat, let cool, and transfer to a bowl.

Spread the shrimp on a sheet pan and place under the broiler until just cooked through, 5 to 7 minutes. Flip the shrimp halfway through.

While the shrimp are cooking, slice the apple and toss it in a small bowl with lemon juice to keep it from turning brown. Remove the apple slices from the bowl, leaving the lemon juice behind, and add them to the bowl with the Brussels sprouts. Whisk the remaining olive oil into the lemon juice, season with salt and pepper, and toss with the salad.

To serve, place 4 shrimp on each plate and arrange the salad mixture on top.

TO MAKE THE HERB OIL: In a blender or food processor, purée the herbs, garlic, and oil until smooth.

ROASTED SALMON SALAD

Serves 4

This dish is on the menu at BG when summer corn is at its peak and the freshest vegetables are brought in still warm from local farms. A ragout of corn, beans, and tomato, and an herb-laden gremolata cut through the richness of a choice piece of salmon. Enjoy this alfresco with a chilled glass of crisp white wine.

2–3 ears fresh corn, shucked
½ pound fresh yellow wax beans or
 haricots verts
1 medium tomato, sliced
6 tablespoons extra-virgin olive oil
3 teaspoons fresh lemon juice
Banyuls Vinaigrette (recipe follows)
4 salmon fillets (6 ounces each),
 skin removed
Salt and freshly ground black pepper
Gremolata (recipe follows)

BANYULS VINAIGRETTE

1 shallot, finely chopped
1 cup Banyuls vinegar, or ¾ cup
 sherry vinegar

½ cup dry white wine
1 cup heavy cream
2 tablespoons (¼ stick) unsalted
 butter, cold
⅛ teaspoon salt
Freshly ground black pepper

GREMOLATA

1 cup grape tomatoes, roasted
1 teaspoon extra-virgin olive oil
1 cup chopped fresh herbs, such as
 basil, chives, and chervil
1 garlic clove, minced
Zest of 2 lemons

Place a rack in the middle of the oven and preheat to 425°F.

Bring a large stockpot of salted water to a boil. Cook the corn on the cob just until tender, about 5 minutes. Using tongs, remove the corn from the water and set aside to cool. Add the beans to the stockpot and blanch for 2 minutes. Remove with a slotted spoon to a bowl of ice water, then drain and place in a large bowl. Slice the kernels from the cobs and add to the beans.

On a sheet pan, toss the tomato slices with 4 tablespoons of the oil, and roast for 10 to 12 minutes, until soft and lightly caramelized.

Combine the roasted tomato with the corn and beans. Add the lemon juice and toss with enough vinaigrette to lightly coat.

Season the salmon with salt and pepper. Warm the remaining 2 tablespoons oil in a large ovenproof skillet over medium heat and sear the fish top side down until brown, 1 to 2 minutes.

Flip the fish, transfer to the oven, and roast for 10 to 12 minutes, until just cooked through.

To serve, place 1 salmon fillet on each of 4 plates, divide the dressed salad mix among them, and drizzle gremolata over the tops.

TO MAKE THE BANYULS VINAIGRETTE: In a small saucepan, combine the shallot, vinegar, and wine. Cook over medium-high heat until reduced to 2 to 3 tablespoons, about 15 minutes. Add the cream and reduce again by half, another 10 to 12 minutes. Add the butter a tablespoon at a time, whisking to incorporate fully before adding the next. Add the salt and season with pepper. Use at room temperature. Refrigerate any left over in an airtight container for up to 5 days.

TO MAKE THE GREMOLATA: Place all the ingredients in a small bowl and toss to combine.

CHICKEN MILANESE

Serves 4

In the classic Milanese style, this dish contrasts a warm, crunchy cutlet with the cool mound of fresh salad served on top. BG's version is made with chicken and baked in the oven rather than fried. The result is moist and, thanks to the Japanese bread crumbs known as panko, delightfully crisp.

4 boneless, skinless chicken breast cutlets (5 ounces each)

2 large egg whites

1 cup finely grated Parmesan cheese

½ cup panko (Japanese bread crumbs)

1 tablespoon chopped fresh thyme

½ cup extra-virgin olive oil

¼ cup sherry vinegar

Salt and freshly ground black pepper

8 cups baby arugula

2 cups cherry tomatoes, halved

1 cup Niçoise olives

Place a rack in the middle of the oven and preheat to 400°F.

Working with 1 piece of chicken at a time, place a cutlet between sheets of plastic wrap and pound with a meat mallet or heavy skillet until flattened to an even ⅓-inch thickness.

Place the egg whites in a shallow dish and lightly whisk. On a large plate, mix together the Parmesan, panko, and thyme. Coat the chicken breasts first with egg white, then the Parmesan mixture.

Mist an ovenproof pan with an olive oil cooking spray and bake the chicken until the crust browns and the chicken is cooked through, 20 to 25 minutes.

In a small bowl, whisk together the oil and vinegar for the dressing. Season to taste with salt and pepper. Combine the arugula, tomatoes, and olives in a large bowl and toss with dressing.

Divide the chicken cutlets among 4 plates and mound the salad on top. Serve immediately. Roasted potatoes make a nice accompaniment.

PAN–SEARED CHICKEN WITH PECANS AND ORANGE ZEST

EDWARD BESS, MAKEUP DESIGNER

Serves 4

Edward can frequently be found behind the counter where his wildly popular cosmetics collection is sold. "I often swap makeup tips with my customers in exchange for ways to improve my culinary skills," he says. "This recipe was a best-kept southern secret from a Texan client." The spicy pecan crust on these tender chicken cutlets is really something special.

4 boneless, skinless chicken breasts (about 1¼ pounds total)
½ cup pecan halves or pieces
¼ cup plain dried bread crumbs
1½ teaspoons freshly grated orange zest

½ teaspoon salt
¼ teaspoon chipotle powder, or to taste
1 large egg white
3 teaspoons canola oil

Working with 1 piece of chicken at a time, place a breast between sheets of plastic wrap and pound with a meat mallet or heavy skillet until flattened to an even ¼-inch thickness.

Place the pecans, bread crumbs, orange zest, salt, and chipotle powder in a food processor and pulse until the pecans are finely ground. Transfer the mixture to a shallow dish.

Whisk together the egg white and 2 tablespoons water in a separate shallow dish. Dip each chicken breast in the egg-white mixture, then dredge both sides in the pecan mixture.

In a large nonstick skillet over medium heat, warm 1½ teaspoons oil and add half the chicken. Cook until browned and no longer pink in the middle, 2 to 4 minutes per side. Transfer to a plate and cover to keep warm. Wipe out the pan with a paper towel and add the remaining oil. Cook the remaining chicken, adjusting the heat as needed to prevent scorching. Serve immediately with a spinach salad.

THAI GRILLED CHICKEN WITH MANGO RICE SALAD

AMY SMILOVIC, DESIGNER, TIBI

Serves 4

Amy lived for a time in Asia, where she acquired a passion for the intense culinary flavors from that part of the world. Known for streamlined, feminine designs, she claims to be a terrible cook, but guarantees that this fail-safe recipe passes muster with even the likes of her friend Joe Bastianich, a highly discerning New York restaurateur. According to Amy, "This meal seriously makes the most average cook look like a rock star."

4 boneless, skin-on chicken breasts, halved
1 tablespoon peanut oil
1 hot green chile, seeded and minced
3 tablespoons sugar
¼ cup fresh lime juice
4 garlic cloves, minced
3 tablespoons fish sauce
1 tablespoon rice wine vinegar
2 tablespoons grapeseed or sunflower oil, if grilling indoors
Dipping Sauce (recipe follows)
Jasmine Rice Salad with Mango (recipe follows)

DIPPING SAUCE
2 tablespoons minced fresh cilantro
1 teaspoon minced hot green chile, or to taste
1 tablespoon sugar
1 tablespoon fresh lime juice
2 tablespoons fish sauce

JASMINE RICE SALAD WITH MANGO
¾ cup jasmine rice
2 tablespoons coarsely chopped roasted, unsalted peanuts
½ cup snow peas, cut in thirds on the diagonal
¼ cup fresh bean sprouts
¼ cup shredded carrot
¼ cup minced peeled English (seedless) cucumber
½ cup ripe finely diced peeled mango
2 tablespoons minced scallions (white and light green parts only)
1 tablespoon minced fresh lemongrass
Salad Dressing (recipe follows)

SALAD DRESSING

- 2 tablespoons minced fresh cilantro
- 2 tablespoons minced fresh mint
- 1–2 garlic cloves, minced
- 2 teaspoons minced peeled fresh ginger
- 1 teaspoon minced hot red chile
- 1 tablespoon lime zest
- 2 tablespoons fish sauce
- 1 teaspoon sugar
- 2 tablespoons rice wine vinegar

Place the chicken in a large resealable plastic bag.

In a medium bowl, combine the peanut oil, chile, sugar, lime juice, garlic, fish sauce, and vinegar and mix thoroughly. Pour this marinade over the chicken, press out excess air, and seal the bag. Marinate at room temperature for at least 1 hour and up to 2 hours. You can marinate the chicken overnight if stored in the refrigerator. Turn occasionally to marinate all parts of the chicken.

If cooking outdoors, light a gas grill 45 to 60 minutes before desired serving time and heat for 15 minutes, covered. Whether using a gas, charcoal, or wood fire, build it to maintain low heat on one side and medium or high on the other.

Place the chicken skin side up over low heat. Turn every 4 or 5 minutes, basting constantly and keeping the grill mostly covered to contain the heat. If the fire flares up, move the chicken to a cooler part of the grill (or turn the gas down). After about 20 minutes, most of the fat will have rendered and the chicken can be moved to the hot side of the grill to finish cooking, 5 to 10 minutes more. When the skin is browned and crisp, transfer the chicken from the grill and let rest for 10 minutes.

If grilling indoors, place a grill pan over high heat and turn on the venting fan. Add 2 tablespoons grapeseed or sunflower oil to the pan, and when very hot, place the chicken on the pan skin side down, turning every 3 minutes or so and basting constantly with marinade.

(continued on next page)

Cook through until the flesh is opaque, 15 to 18 minutes, remove from the pan, and let rest for 10 minutes.

While the chicken is resting, prepare the dipping sauce. Serve the chicken warm or at room temperature, accompanied by the dipping sauce and jasmine rice salad.

TO MAKE THE DIPPING SAUCE: In a small bowl, combine the cilantro, chile, sugar, lime juice, fish sauce, and 2 tablespoons water.

TO MAKE THE JASMINE RICE SALAD WITH MANGO: Cook the rice according to the package directions, either on the stove or in a rice cooker. Once done, cool for 15 minutes.

Place the rice in a large bowl. Add the peanuts, snow peas, bean sprouts, carrot, cucumber, mango, scallions, and lemongrass, stirring well to combine.

Pour the dressing over the rice and gently stir. Serve at room temperature.

TO MAKE THE SALAD DRESSING: In a small bowl, whisk together the cilantro, mint, garlic, ginger, chile, lime zest, fish sauce, sugar, and rice wine vinegar.

INDIAN SUMMER

NAEEM KHAN, DESIGNER

Serves 4 to 6

Starlets and socialites love the ornately embroidered gowns designed by Naeem, whose aesthetic owes much to the beauty and splendor of his native India. It is there he learned this dish from his mother. "It reminds me of my days in my parents' country house in the north," says Naeem, "enjoying summer lunches in the land of heat and dust."

1 whole chicken (about 4 pounds), skinned, washed, and patted dry
Small bunch of cilantro with stems attached, washed and drained
1 medium Spanish onion, coarsely chopped
4 garlic cloves
1–3 serrano peppers (depending on desired heat level)
4-inch knob fresh ginger, peeled and minced
1 tablespoon fresh lemon juice
1 tablespoon plain full-fat yogurt
½ teaspoon sea salt, or to taste
¼ cup ghee or extra-virgin olive oil

Cut the chicken into 8 pieces and place in a large resealable plastic bag.

In a blender or food processor, pulse the remaining ingredients to form a fairly smooth paste. Add to the plastic bag, spread evenly over the chicken, push out the air, and seal the bag. Marinate the chicken at room temperature for up to 2 hours, or up to 4 hours in the refrigerator.

Place a rack in the middle of the oven and preheat to 350°F.

Remove the chicken from the bag and spread out in a baking dish so the pieces do not touch. Cover with foil and bake for 25 minutes. Remove the foil and bake for another 15 to 20 minutes. Watch carefully during the last 10 minutes to make sure the coating does not scorch. Serve with grilled vegetables, rice, and raita.

CHICKEN CURRY
WITH SAFFRON RICE

KATE BETTS, FASHION EDITOR

Serves 6

As someone who regularly hosts big dinners for groups of writers and editors, Kate relies on this bona fide crowd-pleaser. A version of a recipe that originated in *Our Meals*, a cookbook by former New York City Ballet stars Heather Watts and Jock Soto, this chicken curry, says Kate, "can be made the night before—it's even better when it's had time to marinate in its juices!"

3 pounds boneless, skinless chicken breasts and thighs
1 cup all-purpose flour
6 tablespoons (¾ stick) unsalted butter
3 medium yellow onions, diced
1 garlic clove, minced
2 tablespoons curry powder
2 cups low-sodium chicken stock
2 tablespoons Major Grey chutney
2 tart apples, peeled, cored, and sliced
½ cup raisins
½ teaspoon ground ginger
½ teaspoon salt
¼ cup blanched almonds
½ cup heavy cream

Juice of ½ lemon
Saffron Rice (recipe follows)

SAFFRON RICE
2 tablespoons olive oil
1 red onion, chopped
3 garlic cloves, minced
1 red bell pepper, cored, seeded, and diced
2 cups basmati rice
1 tablespoon chopped fresh thyme
4 cups low-sodium chicken stock
Salt and freshly ground black pepper
Pinch of saffron

Chop the chicken into 1-inch cubes and dredge in the flour.

In a large skillet over medium heat, melt 2 tablespoons of the butter and sauté half the chicken until lightly browned all over, about 15 minutes. Transfer to a plate and cover with foil to keep warm. Repeat with 2 more tablespoons of the butter and the rest of the chicken. Add this to the plate. Add 1 tablespoon of the butter, the onions, and garlic to the skillet and sauté until golden, about 10 minutes. Remove from the heat and reserve.

In a large saucepan, melt the remaining 1 tablespoon butter and add the curry powder, chicken stock, chutney, apples, raisins, ginger, and salt. Bring to a boil, then reduce the heat and gently simmer for 30 minutes.

In a small skillet, toast the almonds until golden. Using a mini-processor or a mortar and pestle, pulse or grind the almonds until finely chopped. Heat the cream in a small saucepan on medium-low heat—don't allow to boil. Stir in the almonds and cook for 5 minutes.

Add the chicken, almond cream, and onions to the chutney sauce. Simmer until thickened, 15 to 20 minutes. Add the lemon juice. Serve hot, over saffron rice.

The curry can be made 1 to 2 days ahead of time and kept in the refrigerator.

TO MAKE THE SAFFRON RICE: In a large pot over medium heat, warm the oil and sauté the onion, garlic, and bell pepper until translucent, about 5 minutes. Add the rice, stirring to coat well, then add the thyme and stock. Season to taste with salt and pepper. Bring to a boil, reduce the heat, and simmer, covered, for 15 minutes. Stir in the saffron and cook for another few minutes, until the liquid is completely absorbed. Remove from the heat and let sit, covered, for at least 10 minutes before serving. The rice is best eaten when freshly made.

PAPRIKÁS CSIRKE
(CHICKEN PAPRIKASH WITH SPÄTZLE)

LINDA FARGO, SENIOR VICE PRESIDENT, FASHION OFFICE
AND STORE PRESENTATION, BERGDORF GOODMAN

Serves 6

Described by *Time* magazine as the store's "ambience master and gatekeeper of style," the always glamorous Linda Fargo is in charge of fashion direction at Bergdorf's, from the clothes that fill the store to the extraordinary window displays. When she turns her talents to the kitchen, it's most often to whip up a pot of her father's favorite traditional Hungarian dish. "It's all about the beautiful flavor of paprika, the regional spice that comes in sweet or hot versions," she says. "Mix them as you like, and the aroma of Hungary will fill your home!" For this recipe, Linda suggests using authentic Hungarian paprika from Szeged and, in a pinch, substituting egg noodles for the spätzle.

3 pounds chicken thighs and/or
 breasts, with the skin on and bones in
Kosher salt and freshly ground black
 pepper
2 tablespoons olive oil
1 large yellow onion, diced
3 tablespoons sweet or hot Hungarian
 paprika, or a combination
3 large tomatoes, large dice
2 green bell peppers, large dice

4–5 cups low-sodium chicken stock
 or water
3 tablespoons sour cream
Spätzle (recipe follows)

SPÄTZLE

2 cups all-purpose flour
¾ teaspoon salt
3 large eggs, beaten

Rinse the chicken and pat it dry. Salt and pepper both sides of each piece. Drizzle the 2 tablespoons oil on the bottom of a large stockpot, then heat over a medium-high flame. Wait until the pot is hot, then place the chicken skin side down on the bottom. Brown for 2 to 3 minutes. Flip the chicken to sear the other side quickly for about another minute. Remove the chicken to a plate and set aside, uncovered.

Add the onion and paprika to the stockpot and sauté over medium heat, seasoning with salt and black pepper. After about 10 minutes, when the onion is soft and translucent, add the tomatoes and green pepper. Cook for another 5 to 7 minutes.

Place the seared chicken and whatever juices have collected on the plate into the pot. Pour in the stock or water to cover the chicken pieces. Don't submerge them fully; about three-quarters of the way is good. Simmer, covered, on medium heat for about 1 hour.

After the first hour, reduce the heat to low and cook at a very slow simmer for another 60 to 90 minutes, or longer if you can. When the chicken is done, it should be falling off the bone. Taste the stock to make sure it is well seasoned, adding more salt, pepper, or paprika if necessary. Just before serving, stir in the sour cream.

Serve hot, with the traditional accompaniment of spätzle ("little dumplings") or thick egg noodles.

TO MAKE THE SPÄTZLE: In a large bowl, combine the flour and salt. Add the eggs and mix well. Pour in ½ to ¾ cup water while continuing to mix, adding only enough to make a sticky and stretchy dough.

Bring a pot of lightly salted water to a boil. Use a spätzle maker to drop the batter into the boiling water, or place a colander with ¼-inch holes over the pot and use a rubber spatula to push the batter, a cup at a time, through the holes and into the water. Boil the spätzle until firm, 2 to 3 minutes. Drain well.

KHORESH–E KARAFS
(PERSIAN CELERY STEW)

CHARLOTTE DELLAL, DESIGNER, CHARLOTTE OLYMPIA

Serves 6

Known for embracing a retro Hollywood glamour in both her own look and the design of her shoe collection, London-based Charlotte also incorporates a touch of English eccentricity. Her go-to recipe in the kitchen, however, is not typical British fare. "My Iranian mother-in-law is the most amazing cook and she taught me how to make this—my favorite dish," says Charlotte. This veal stew boasts the bright, tangy notes and savory succulence typical of Persian cuisine.

2 heads of celery
5 tablespoons olive oil
2 bunches of fresh parsley
Bunch of fresh mint
1 large onion, finely chopped
1 teaspoon turmeric
2 pounds veal, cut into 1-inch cubes

Freshly ground black pepper
½ teaspoon ground saffron
2 tablespoons verjus, or juice from
 2 whole lemons
1 teaspoon unsalted butter
Kosher salt

Trim the celery, discarding the leaves, and slice the stalks into ¾-inch pieces.

In a large saucepan over medium heat, warm 2 tablespoons of the oil and sauté the celery until slightly softened, 15 to 20 minutes. Set aside.

Wash and thoroughly dry the parsley and mint. Remove the leaves, discarding the stems, and finely chop. In a small skillet, warm 1 tablespoon of the oil over medium-low heat and sauté the herbs for about 10 minutes. Do not let them turn black. Set aside.

In a large pot over medium-high heat, warm the remaining 2 tablespoons oil. Add the onion and cook until golden, 5 to 10 minutes, then stir in the turmeric.

Mix the veal with the onion and continue to cook for another 10 minutes, lightly browning the meat on all sides. Season with pepper and add the saffron, stirring once to combine.

Add the herbs and celery to the veal, and enough water to cover, about 2 cups. Bring to a boil, reduce the heat to low, and simmer, covered, for 1 hour. Khoresh is meant to be quite thick, so if it appears watery, leave the lid partially off to allow evaporation; if it is too dry, add small amounts of cold water. Add the verjus and butter and continue to cook for 30 minutes more. Taste and season with salt, as needed. Serve with jasmine rice.

BEEF SHORT RIBS WITH WILD MUSHROOM BREAD PUDDING

Serves 6

This hearty dish is perfect après-ski or après-walking-around-the-cold-city-all-day. Few things are better on a winter's night than wine-drenched, slow-braised meat with a warm bread pudding to soak up the juices. The recipe doesn't require much more than a little planning ahead, as the ribs are browned and left to marinate overnight. The bread pudding can also be made the day prior and reheated before serving.

6 flanken-style short ribs (about 4 pounds), cut into 2-inch-thick pieces
Kosher salt and freshly ground black pepper
2 tablespoons vegetable oil
1 large onion, diced
2 carrots, sliced
3 celery stalks, sliced
3 garlic cloves, thickly sliced
1 750 ml bottle dry red wine
4 sprigs of thyme
3 cups chicken stock
Wild Mushroom Bread Pudding (recipe follows)

WILD MUSHROOM BREAD PUDDING
4 cups ½-inch cubes of brioche (including crust)
½ cup diced carrot
½ cup diced butternut squash
2 teaspoons olive oil
Salt and freshly ground black pepper
1 tablespoon unsalted butter
½ cup sliced leeks (white and tender light green parts only)
1 cup sliced assorted fresh wild mushrooms, such as any combination of chanterelles, black trumpets, hen of the woods, and porcini
3 large eggs
2 large egg yolks
2½ cups heavy cream
½ cup grated Parmesan cheese
½ cup grated Gruyère cheese
1 tablespoon chopped fresh thyme

Generously season the ribs with salt and pepper. Cook the ribs in batches, as necessary, to avoid crowding the pan. In a large skillet over medium-high heat, warm the oil and sear the ribs, turning once, until browned and crusty, 10 to 15 minutes. Transfer to a shallow baking dish and arrange in a single layer.

Discard all but 2 tablespoons of the fat from the skillet. Add the onion, carrots, celery, and garlic and cook over medium heat, stirring occasionally, until very soft and lightly browned, 10 to 15 minutes. Pour in the wine, scraping up any brown bits from the bottom of the pan. Add the thyme and bring to a boil over high heat. Pour the hot marinade over the ribs and cool. Cover and refrigerate overnight, turning the ribs once.

The following day, place a rack in the lower third of the oven and preheat to 350°F.

Transfer the ribs and marinade to a large, heavy pot with a lid, like a Dutch oven. Add the stock and bring to a boil. Cover and cook in the oven for 1½ hours, until the meat is tender but not falling off the bone. Uncover and braise for 45 minutes longer, turning the ribs once or twice, until the sauce is reduced by about half and the meat is fork-tender.

Raise the oven rack to the upper third and preheat the broiler.

Transfer the meat to a clean shallow baking dish, discarding the bones as they fall off. Strain the sauce into a heatproof 4-cup measuring cup and skim off as much fat as possible; there should be 2 to 3 cups remaining in the cup. Pour this sauce over the meat and let it rest for 10 minutes. Transfer the meat to a baking sheet. Warm the sauce from the baking dish in a small pan over low heat.

Broil the meat, turning once or twice, until glazed and sizzling, 5 to 10 minutes. Keep a close watch to avoid burning. Divide the meat among 6 plates and spoon warmed sauce on top. Serve with the wild mushroom bread pudding.

(continued on next page)

TO MAKE THE WILD MUSHROOM BREAD PUDDING: Place a rack in the middle of the oven and preheat to 325°F.

Spray six 6-ounce soufflé dishes with nonstick cooking spray. Line a baking sheet with parchment paper and set aside.

Spread the brioche on the baking sheet and toast in the oven for about 15 minutes. Transfer to a large bowl. Raise the oven temperature to 425°F.

Combine the carrot, squash, and oil. Season with salt and pepper and spread on the baking sheet. Roast until soft, about 20 minutes. Remove from the oven and reduce the temperature to 350°F.

In a small pan over medium heat, melt the butter and sauté the leeks for 5 minutes, until soft. Add the mushrooms, season with salt and pepper, and continue to cook until soft, about another 5 minutes.

In a medium bowl, whisk together the eggs and yolks with the cream to make the custard. Put the Parmesan, Gruyère, and thyme in the large bowl with the brioche and toss to combine. Mix in the custard. Let sit for 30 minutes to allow the bread to absorb the liquid.

Spoon the mixture into the soufflé dishes and bake until the top is brown and the custard is set, about 45 minutes.

CROQUE MONSIEUR

Makes 4 sandwiches

This iconic ham-and-cheese sandwich is a classic of the French repertoire that dates back more than a hundred years. BG stays true to the original, spreading a luscious layer of béchamel sauce on top and then running the sandwich under the broiler until golden and bubbling.

8 tablespoons (1 stick) unsalted butter

½ cup diced onion

½ cup all-purpose flour

2 cups whole milk

8 ½-inch slices of brioche (with crust)

½ cup Dijon mustard

20 ounces Black Forest ham, thinly sliced

2 cups shredded Gruyère cheese

To make the béchamel sauce, in a medium saucepan over medium heat, melt the butter and cook the onion until translucent, about 10 minutes. Add the flour and cook for an additional 5 minutes, until it becomes a golden paste. Whisk in the milk and keep stirring until the sauce thickens. Strain out and discard the onion. Cool the béchamel sauce slightly before proceeding.

Place a rack in the top third of the oven and preheat to 350°F.

Cover a baking sheet with parchment paper. Lay the brioche on the baking sheet. Spread Dijon mustard on 1 side of every slice and top half of the slices with equal portions of the ham. Cover with the remaining 4 slices of brioche, mustard side facing in. Spread a thin layer of béchamel sauce on top of each sandwich. Top with a thin layer of cheese.

Bake in the oven until golden brown and bubbling, 5 to 7 minutes. Serve hot, accompanied by baby greens tossed with a light vinaigrette.

HAL'S HOT FOR CHILI

HAL RUBENSTEIN, WRITER

Serves 6 to 8

A founding editor of *InStyle* magazine—and a legend in the fashion world—Hal Rubenstein was raised in the Bronx, where chili was not exactly a local specialty. It wasn't until a friend, the award-winning journalist and Texas native Linda Ellerbee, introduced him to the real thing that he developed a passion for it. "Since that first bowl in her kitchen, I have read and devoured at least two dozen chili recipes before devising the one below," says Hal. "Just remember that if you put beans in it, you can't call it chili."

3 pounds beef chuck, fat trimmed and cut into 1-inch cubes
Sea salt and freshly ground black pepper
1 teaspoon garlic powder
3 tablespoons pasilla chile powder
3 whole dried ancho chiles
2 tablespoons olive oil
2 carrots, diced
1 large Spanish onion, diced
1 celery stalk, diced
2 green bell peppers, cored, seeded, and diced
1 red bell pepper, cored, seeded, and diced

10 garlic cloves, minced
2 teaspoons chopped fresh oregano
2 teaspoons chopped fresh thyme
4 ounces tomato paste
1 tablespoon sugar
1 tablespoon white vinegar
2 tablespoons all-purpose flour
1 quart beef stock
4 plum tomatoes
1 tablespoon ground cumin
2 tablespoons ground coriander
Sriracha or other red chili sauce
Grated Monterey Jack cheese

In a large bowl, mix together the beef, 1 tablespoon salt, ½ teaspoon pepper, garlic powder, and chile powder. Let sit for 20 minutes.

Meanwhile, prepare the ancho chiles. Remove the stems and cut open the chiles to remove the ribs and seeds. In a dry, heavy skillet over low heat, toast for just 10 seconds on each side, then soak in hot water until pliable, about 20 minutes. Remove from the water, dry, and mince. Set aside.

In a large pot over medium-high heat, warm the oil and brown the beef for 7 to 10 minutes. Do this in batches if necessary, being careful not to crowd the pan. Transfer the beef to a plate.

In the same pot, stir together the carrots, onion, celery, green and red bell peppers, garlic, oregano, and thyme. Season to taste with salt and pepper. Reduce the heat to medium

and cook until softened, 5 to 10 minutes. Add the tomato paste, sugar, and vinegar, mixing to coat. Cook 2 to 3 minutes, stirring often.

Return the meat to the pot and sprinkle with the flour, stirring to mix in quickly. Stir in the stock in 4 increments to help prevent lumps. Add the tomatoes, cumin, coriander, and minced ancho chiles, stirring to make sure the ingredients are evenly distributed. Bring to a boil, then reduce the heat and simmer, covered, until meat becomes tender, about 2 hours.

Taste and add Sriracha sauce, 1 tablespoon at a time, to achieve the desired level of heat. Cool the chili slightly, then serve in bowls topped with cheese. Chili tastes even better reheated the next day, after the flavors have had longer to meld.

SHEPHERD'S PIE

TABITHA SIMMONS, DESIGNER

Serves 4 to 6

A former model turned stylist and shoe designer, Tabitha has many creative talents, and they, along with her English sensibility, extend to the kitchen. "Shepherd's pie is part of my British heritage and upbringing," she says. "I remember coming home from school to find it on the table for family dinner quite often." Serve it with a simple salad for a hearty and warming meal.

1 tablespoon vegetable oil

1 teaspoon plus 1½ tablespoons unsalted butter

1 medium onion, finely chopped

1 pound lean ground beef

2 cups crushed tomatoes

1¼ cups beef stock

3 tablespoons Worcestershire sauce

2 teaspoons oregano

3 bay leaves

2 pounds Yukon Gold potatoes

1 cup heavy cream

Salt and freshly ground black pepper

4 medium carrots, boiled until tender and diced

1½ cups cooked peas

⅓ cup grated sharp cheddar cheese (optional)

Small bunch of watercress, washed and trimmed (optional)

Place a rack in the middle of the oven and preheat to 350°F.

In a large saucepan over medium-low heat, warm the oil and 1 teaspoon butter and sauté the onion until soft, about 5 minutes. Increase the heat to medium, add the beef, and cook until completely browned, separating the meat as it is cooking to prevent clumps. Add the tomatoes, stock, Worcestershire, oregano, and bay leaves, and simmer, stirring occasionally, until the meat is tender, about 1 hour.

While the meat is cooking, peel the potatoes and cut them into quarters. Place them in a large stockpot and cover with cold, salted water. Bring to a boil and cook until tender, about 20 minutes. Drain well. Meanwhile, heat the cream and 1½ tablespoons butter in a small saucepan.

Put the potatoes through a ricer and then mix in the heated cream. Season to taste with salt and pepper. Set aside.

When the meat is done, add more salt, pepper, or Worcestershire to taste. Transfer the meat to an ovenproof baking dish and mix in the carrots and peas. Spread an even layer of mashed potatoes over the meat and top with cheddar. Bake until golden brown and bubbling, 30 to 40 minutes. Serve garnished with watercress, if desired.

BAKED EGGS with CANDIED BACON

JOE ZEE, EDITOR IN CHIEF AND CREATIVE OFFICER, YAHOO FASHION

Serves 6

A fashion authority known for his discerning eye, Joe is also the host of the original Sundance television program *All on the Line*. While living in the Hollywood Hills during the filming of his show, he had another moment of drama as he was cooking an early breakfast for a houseful of friends. "In an effort to speed up the bacon for this recipe, I cranked up the oven to broil," he recalls. "It ignited a major grease fire that brought seven firemen with a hose and all their equipment." In the end, breakfast was salvaged, and this recipe lives on—though the bacon is baked, not broiled!

½ cup chopped tomatoes

2–3 fresh basil leaves

¼ cup cubed fresh mozzarella

Salt and freshly ground black pepper

2 teaspoons olive oil, plus more
 as needed

Red pepper flakes

½ garlic clove, minced

3 ounces Italian sausage, removed
 from the casings

½ small shallot

1 tablespoon chopped fresh parsley,
 plus more for garnish

⅓ small leek, finely chopped (white
 and light green parts only)

⅔ cup mushrooms, sliced

Small handful of spinach

⅓ small sweet onion, diced

6 large eggs

6 teaspoons heavy cream

Maldon sea salt

6 teaspoons grated Parmesan cheese

Candied Bacon (recipe follows)

CANDIED BACON

½ cup (packed) light brown sugar

Dash of cinnamon

Dash of ground nutmeg

Cayenne

1 pound thick-cut bacon

Place a rack in the middle of the oven and preheat to 350°F. Butter 6 individual ramekins.

In a small bowl, mix together the tomatoes, basil, mozzarella, and a pinch each of salt and black pepper. Set aside.

In a skillet over medium heat, warm 1 teaspoon of the oil and sauté the pepper flakes, garlic, and sausage until the meat is cooked through. Add the shallot and sauté until it becomes translucent, 2 to 3 minutes, then remove from the heat and stir in parsley. Transfer to another small bowl and set aside.

Wipe out the skillet, add 1 teaspoon of the oil, and sauté the leek, mushrooms, spinach, and onion over medium heat. Season with a pinch each of salt and black pepper and cook until the spinach is wilted and the vegetables are cooked through, about 5 minutes. Set aside.

Fill 2 ramekins with the mozzarella, basil, and tomato mixture. Fill another 2 ramekins with the sausage mixture. Fill the last 2 ramekins with the mushroom filling.

Into each ramekin, crack 1 egg and add 1 teaspoon of heavy cream, a dash of oil, black pepper to taste, a pinch of Maldon salt, and a sprinkle of

Parmesan. Bake until the egg whites are opaque and the yolks begin to firm up, 12 to 17 minutes, depending on how firm you like them. Remove from the oven and garnish with chopped parsley. Serve with crusty bread and Candied Bacon.

TO MAKE THE CANDIED BACON:
Place a rack in the middle of the oven and preheat to 350°F.

In a large bowl, combine the sugar, cinnamon, nutmeg, and cayenne to taste and mix well. Coat each strip of bacon with the sugar mixture by thoroughly pressing it into both sides of the meat. Set aside.

Line a baking sheet with parchment paper. Generously coat a wire rack with nonstick cooking spray and fit it on the baking sheet. Lay the bacon on the rack without crowding and sprinkle any remaining sugar mixture on top.

Bake on a center rack in the oven, 20 to 30 minutes. The bacon should start to caramelize after 10 to 15 minutes and then become crispy around the edges. Remove the bacon from the oven and transfer it to a plate; do not lay it on paper towels, as it will stick to them.

BRUSSELS SPROUT FAUX PASTA

BOBBI BROWN, MAKEUP ARTIST AND FOUNDER, BOBBI BROWN COSMETICS

Serves 4

A beauty maven who celebrates women's individuality, Bobbi is also a working mother who knows how to satisfy her family's appetites and needs. "This recipe came about because I had to find a way around everybody's different dietary restrictions," she says. "My sons eat only brown rice pasta, our exchange student ate only white pasta, and I don't eat pasta at all!" This dish is packed full of vegetables but can also be enhanced with shrimp or chicken or spiced with red pepper flakes.

2 tablespoons olive oil

1–2 garlic cloves, chopped

½ cup chopped onion

1–2 teaspoons red pepper flakes, or to taste (optional)

1 pound Brussels sprouts, thinly sliced

½ pound green beans

½ pound baby kale

1 24-ounce jar best-quality tomato sauce (Bobbi uses Rao's)

1 pound cooked chicken or shrimp, cut into bite-size chunks (optional)

Salt

In a large, deep skillet, warm the oil on medium heat and sauté the garlic and onion until soft and translucent, about 10 minutes. Add the pepper flakes (if desired) and Brussels sprouts and sauté for 2 to 3 minutes. Add the beans and kale, and sauté until the greens are wilted. Stir in the tomato sauce and the chicken or shrimp (if using) and simmer until heated through, 8 to 10 minutes. Season with salt to taste.

MEYER LEMON AND ARUGULA PASTA

DEBORAH NEEDLEMAN, EDITOR IN CHIEF,
T: THE NEW YORK TIMES STYLE MAGAZINE

Serves 4

In bringing the culture of fashion to readers, Deborah encourages them to think about both the business and the craftsmanship behind the glamour. "When I invited an old friend and his new girlfriend—then the food editor of the *New York Times*—to dinner, I knew I had to figure out something special to make," she says. "Something that seemed tossed off but that also subtly signaled I knew my way around the culinary landscape." This recipe was such a hit, it ended up in the girlfriend's book, *Cooking for Mr. Latte,* by Amanda Hesser.

½ cup finely grated Parmesan cheese, or more, to taste

2 big handfuls of baby arugula, chopped

2 Meyer lemons

1 pound fresh linguine (or substitute dried)

½ cup crème fraîche

Salt and freshly ground black pepper

Set a large pot of well-salted water to boil. Put the Parmesan in a large serving bowl. Add the arugula. Zest and juice the lemons, adding the zest to the bowl and setting the juice aside.

Cook the linguine in the boiling water according to the package instructions until just al dente. Briefly drain, then transfer the still water-slicked pasta to the bowl. Add the lemon juice and toss everything together, until the arugula is wilted and the cheese melted. Stir in the crème fraîche and season with salt and pepper. Serve immediately.

BÁNH MÌ
(CARAMELIZED PORK)

GILLES MENDEL, DESIGNER, J. MENDEL

Serves 4

The French have long been infatuated with Southeast Asian cuisine, so it makes sense that Gilles's go-to recipe for summer entertaining is this classic Vietnamese street food. "I wish I had discovered it while wandering the streets of Vietnam, but it's nearly impossible to get me out of my atelier!" says Gilles. "My girlfriend, who is an amazing cook, taught me how to make this dish."

1½ pounds pork tenderloin
3 tablespoons fish sauce
2 tablespoons pure maple syrup
1 tablespoon (packed) light brown sugar
2 tablespoons soy sauce
½ teaspoon toasted sesame oil
2 garlic cloves, minced
1 teaspoon minced peeled fresh ginger
1 scallion, thinly sliced (white and green parts)
½ teaspoon freshly ground black pepper
2 tablespoons vegetable oil
4 6-inch slices of baguette

Best-quality mayonnaise
Pork pâté (optional, but recommended)
Red leaf lettuce
Pickled Vegetables (recipe follows)
Sliced jalapeño peppers
Fresh cilantro

PICKLED VEGETABLES
¼ pound baby carrots
Bunch of red radishes
½ cup water
1 cup apple cider vinegar
1 tablespoon salt
2 tablespoons sugar

Cut the tenderloin across the grain into ½-inch pieces. Place each piece between two pieces of plastic wrap and flatten to a uniform ¼-inch thickness using a meat pounder or rolling pin.

To make the marinade, mix together the fish sauce, maple syrup, sugar, soy sauce, sesame oil, garlic, ginger, scallion, and pepper in a large bowl. Taste to make sure it's the perfect balance of sweet and savory, and add more soy, salt, or sesame oil, as needed. Add the meat to the marinade and use your hands or a large spoon to coat every piece. Allow the flavors to meld at room temperature for 10 to 30 minutes.

It's best to cook the pork on an outdoor grill, but a cast-iron grill pan works fine in the kitchen. Either way, the surface needs to be very hot—so turn on the vent fan!

Add the oil to the meat and stir to coat. On a piping-hot surface, sear the first side of the meat until very dark brown, then flip and sear the second side. The meat is so thin that it cooks very quickly, usually in 1 to 2 minutes per side. Be careful not to overcook it.

To assemble the sandwiches, split each baguette slice lengthwise and spread mayonnaise on 1 side and pâté (if desired) on the other. Add the lettuce, meat, pickled vegetables, jalapeños, and cilantro.

TO MAKE THE PICKLED VEGETABLES: Cut the carrots lengthwise into quarters (or sixths, if using thicker vegetables). Slice the radishes into thin circles. Mix together the water, vinegar, salt, and sugar in a bowl or jar, taste for seasoning, and add the vegetables. Let the flavors meld for at least an hour before eating. The pickles will keep in the refrigerator for several days.

CAULIFLOWER STEAKS
WITH SAUCE GRIBICHE

Serves 4

Quite a few BG regulars are vegetarians, and the restaurant makes an effort to offer them something above and beyond the expected fare. As the trend for placing vegetables at center stage becomes more widely embraced, creativity and innovation are essential to developing dishes with such layered flavors that carnivores are intrigued, too. These cauliflower steaks are a perfect example of this modern cuisine.

Large head of cauliflower
5 tablespoons olive oil
1 Anjou pear
Salt and freshly ground black pepper
Sauce Gribiche (recipe follows)
8 cups baby spinach
⅓ cup golden raisins

SAUCE GRIBICHE
3 large, hard-cooked egg yolks
1 tablespoon fresh lemon juice
1 tablespoon Dijon mustard
½ cup grapeseed oil
2 tablespoons capers
4 garlic cloves, roasted and mashed

Bring a large stockpot filled with generously salted water to a boil. Blanch the whole cauliflower for 3 to 4 minutes, then plunge it into a large bowl of ice cubes mixed with cold water. Once the cauliflower has cooled, remove any leaves and trim the stem, leaving the core intact. Place the cauliflower stem side down on a cutting board, and using a large chef's knife, cut it into 4 equal slices.

Place a rack in the middle of the oven and preheat to 350°F.

Line a baking sheet with parchment paper. In a large skillet, warm 2 tablespoons of the oil over medium-high heat and sear the cauliflower slices on both sides until golden brown, 4 to 6 minutes. Transfer to the baking sheet and set aside.

Halve and core the pear, then slice into 8 pieces. Add 1 tablespoon of the oil to the skillet and sauté the slices until golden brown and caramelized, 3 to 4 minutes. Season with salt and pepper. Transfer to a small, oven-safe baking dish and roast for 15 minutes. Remove from the oven and set aside.

Spoon the sauce over the cauliflower slices and warm in the oven for 3 to 4 minutes.

Meanwhile, heat the remaining 2 tablespoons oil in the skillet and sauté the spinach with the raisins until the greens are wilted. Add the pear and stir gently to combine.

To serve, divide the cauliflower slices among 4 plates and spoon the spinach mixture on top.

TO MAKE THE SAUCE GRIBICHE:
In a small bowl, whisk together all the ingredients until emulsified.

MUSHROOM AND THYME QUINOA RISOTTO

ANDREA LIBERMAN, DESIGNER, A.L.C.

Serves 6 to 8

In her various incarnations as a retailer, celebrity stylist, and designer, Andrea has always been known for her discerning eye and an affinity for the urban nomad. The recipe she contributes here is one of her go-to favorites. "I am all about a contradiction!" she says. "And, like everything I enjoy, this easy dish manages to be both healthy and decadent." This "risotto" is as comforting as pasta but has the nutritional benefits of quinoa.

1 cup quinoa, rinsed
2 tablespoons olive oil
1½ cups chopped yellow onions
1 garlic clove, minced
1 8-ounce package of cremini mushrooms, sliced (2½ cups)

6 ounces fresh shiitake mushrooms, stemmed and sliced (2 cups)
3 teaspoons chopped fresh thyme
1 cup dry white wine
Salt and freshly ground black pepper
½ cup grated Parmesan cheese

In a medium saucepan over high heat, bring 2 cups salted water to a boil (or substitute chicken stock for a richer flavor). Add the quinoa, reduce the heat to medium-low, cover, and simmer until the water is absorbed and the quinoa is tender, about 13 minutes.

Meanwhile, in a large skillet over medium-high heat, warm the oil and sauté the onions until they begin to brown, 5 minutes. Reduce the heat to medium and add the garlic, stirring for 30 seconds. Add the mushrooms and 2½ teaspoons of the thyme. Sauté until the mushrooms are tender, 6 minutes. Add the wine and raise the heat to high, stirring until the wine is reduced and the liquid is syrupy, 2 minutes. Remove the pan from the heat.

Mix the cooked quinoa into the mushroom mixture and season with salt and pepper. Fold in the Parmesan cheese and sprinkle the remaining ½ teaspoon of thyme on top as a garnish.

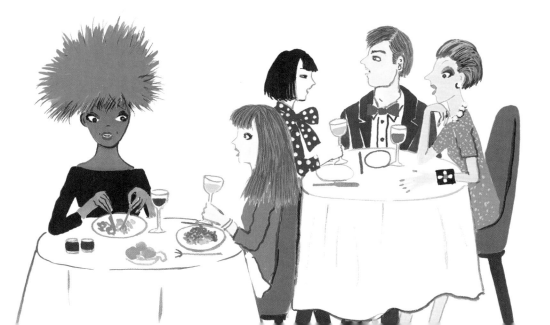

SAVORY VEGETABLE ROULADE

HOWARD SLATKIN, INTERIOR DESIGNER

Serves 8

Howard is a devotee of all things luxurious, and his rarefied taste is the essence of Fifth Avenue style. "As thanks for designing the interiors of her New York apartment, Deeda Blair gave me a beautiful album containing recipes of some of the delicious food she has fed me over our two decades of friendship," he says. Among them is this favorite dish he often serves when entertaining, either for lunch or dinner. Seasonal vegetables may be substituted for those listed here.

10 ounces Parmesan cheese, grated and divided into thirds

1 ⅓ cups fresh whole wheat bread crumbs

8 large eggs, separated

10 ounces light or fat-free cream

1 teaspoon cayenne

Freshly ground black pepper

2 tablespoons hot water

Salt

½ cup chopped fresh parsley

4 tablespoons best-quality mayonnaise

4 tablespoons Greek yogurt or sour cream

½ cup chopped fresh dill

2 large leaves iceberg lettuce, shredded

1 cup chopped arugula

1 cup chopped watercress

4 scallions, finely chopped

½ cup finely chopped fresh mint

24 cherry tomatoes, quartered (about 2 cups)

1 cup thinly sliced asparagus tips

5 radishes, thinly sliced

1 ripe avocado, pitted, peeled, and diced

½ cup diced cucumber

Place a rack in the middle of the oven and preheat to 400°F.

Line a 15½ × 10½-inch jelly roll pan with parchment paper and sprinkle with the first third of the Parmesan. In a medium mixing bowl, combine the second third of the Parmesan, bread crumbs, egg yolks, and cream. Add the cayenne and freshly ground black pepper to taste. Stir in the hot water to soften the mixture.

In a clean, dry mixing bowl, whisk the egg whites with a pinch of salt until soft peaks form. Fold the cheese mixture into the egg whites and spread on the lined pan.

Bake in the oven for 20 to 22 minutes, or until risen, golden brown, and slightly firm to the touch. Remove and cool slightly, about 10 minutes. Cover the roulade with a damp cloth to prevent it from drying out; leave to cool at room temperature.

While the roulade is cooling, make the filling. Set aside 1 tablespoon of the parsley to use as a garnish. In a small mixing bowl, mix the mayonnaise and yogurt with the dill and remaining parsley and set aside. In a medium mixing bowl, combine the iceberg, arugula, and watercress.

Sprinkle another sheet of parchment paper with the last third of the cheese. Turn the roulade out onto this paper and gently peel off the parchment from the bottom. Spread the mayonnaise-yogurt filling on the exposed side of the roulade. Sprinkle with the scallions, mint, tomatoes, asparagus, radishes, avocado, and cucumber. Top with the lettuce mixture. Season with salt and pepper.

Roll up the roulade fairly loosely with the help of the parchment paper and carefully transfer to a serving dish, discarding the paper after. Don't roll too tightly or the filling will be squeezed out. And don't worry if it splits. Sprinkle with the reserved parsley and serve.

WILD MUSHROOM, SPINACH, AND GRUYÈRE QUICHE

Serves 8

Rich yet light, quiche is easy to make and the perfect centerpiece for lunch or brunch. It's ideal for entertaining, as the full entrée can be baked ahead of time—and even frozen—then reheated. The dough, too, can be made ahead. BG served this lovely vegetarian option at an event for designer Stella McCartney.

FOR THE CRUST

1½ cups all-purpose flour

2 teaspoons chopped fresh thyme

¼ teaspoon salt

8 tablespoons (1 stick) cold unsalted butter, cut into small cubes

1 large egg yolk

1 teaspoon vinegar or fresh lemon juice

Ice water

FOR THE FILLING

1 tablespoon unsalted butter

4 cups baby spinach

Salt and freshly ground black pepper

2 cups sliced wild mushrooms, such as any combination of fresh chanterelles, porcini, black trumpet, and hen of the woods

1 cup shredded Gruyère cheese

6 large eggs

2 large egg yolks

1 cup milk

1 cup heavy cream

2 tablespoons chopped fresh parsley

TO MAKE THE CRUST: In a large bowl, whisk together the flour, thyme, and salt. Using a pastry blender or 2 knives, cut in the butter until the dough resembles coarse crumbs with a few larger pieces.

In a liquid measuring cup, whisk together the egg yolk with the vinegar. Add enough ice water to make ⅓ cup. Drizzle over the dry ingredients, stirring briskly with a fork to form a ragged dough. Add additional ice water by the tablespoon, as needed. Press into a disk, wrap in plastic wrap, and refrigerate until cold, about 30 minutes.

Place a rack in the middle of the oven and preheat to 400°F.

On a lightly floured surface, roll out the dough to a ¼-inch thickness. Fit into a 9-inch pie pan or quiche dish. Trim the edge, leaving a 1-inch overhang, then fold under the pastry rim and flute the edge. Prick all over with a fork. Refrigerate for 30 minutes.

Line the pie shell with foil and fill with pie weights or dried beans. Bake for 20 minutes. Remove the weights and foil and return the shell to the oven, baking an additional 10 to 15 minutes, or until light golden. Cool in the pan on a wire rack. Reduce the oven temperature to 350°F.

TO MAKE THE FILLING: In a large skillet over medium heat, melt 1 teaspoon of the butter and add the spinach. Season with salt and pepper and cook until just wilted. Scrape into a bowl, and when cool, squeeze out the extra liquid.

Add the remaining butter to the pan, then the mushrooms. Season with salt and pepper and sauté, stirring occasionally, until softened, about 4 minutes. Spread in the pie shell along with the spinach and Gruyère.

In a large bowl, whisk together the eggs, egg yolks, milk, cream, ½ teaspoon salt, and ¼ teaspoon pepper. Stir in the parsley. Set the pie shell in a pan on top of a baking sheet and pour in the custard mixture.

Bake until the filling is set and a knife inserted into the center comes out clean, about 50 minutes. If the pastry starts to brown too quickly, cover the rim with foil. Cool in the pan on the rack for 10 minutes before serving.

NOTE: To make ahead of time, bake the quiche, then cool, cover with foil, and refrigerate for up to 24 hours. To reheat, leave the foil cover on and bake on the middle rack of a preheated 325°F oven for about 20 minutes. The dough may be made up to 3 days in advance of serving and refrigerated.

CARAMELIZED ONION AND FONTINA CHEESE PIZZA

JAMES AGUIAR, NATIONAL FASHION DIRECTOR, MODERN LUXURY

Serves 8

An authority on luxurious living, James oversees ten online lifestyle magazines and still finds the time to cook! His pizza, renowned throughout the fashion world, makes an appearance at all his holiday gatherings. "People clamor for it so much that I purposely don't serve it until later in the evening," he says. "But it never fails that [Bergdorf Goodman senior vice president] Linda Fargo is in the kitchen by 10 P.M. looking for it." James sometimes buys the dough from his local pizza parlor to save time and encourages others to do the same.

1 envelope active dry yeast
1 cup warm water
2 pinches of sugar
4 tablespoons extra-virgin olive oil
2 teaspoons chopped fresh thyme, plus whole sprigs for garnish
Salt

2⅓ cups all-purpose flour
3 tablespoons unsalted butter
2½–3 pounds red onions, thinly sliced
Freshly ground black pepper
¼ cup Madeira wine
¾ pound Italian fontina cheese, sliced or crumbled

In a large bowl, mix the yeast with the water and 1 pinch of the sugar and let stand until foamy, 5 minutes. Add 1 tablespoon oil, 1 teaspoon thyme, and 1 teaspoon salt. Gradually stir in 2 cups flour to form a very soft, wet dough. Turn out onto a lightly floured surface and knead, working in about ⅓ cup more flour, until the dough is soft and silky, about 10 minutes. Shape into a ball and place in a large, lightly oiled bowl. Cover and let rise until doubled in bulk, about 1 hour at room temperature.

In a large skillet over medium-high heat, warm 3 tablespoons oil and the butter. Add the onions, season with salt and pepper and a large pinch of sugar, and sauté until soft, 5 to 10 minutes. Reduce the heat and simmer, stirring occasionally, until the onions reach a jamlike consistency, 45 to 60 minutes.

Add the Madeira, raise the heat, and bring to a boil to reduce the liquid, another 10 minutes. Transfer the onions to a plate and cool.

Place a rack in the middle of the oven and preheat to 450°F. Line a baking sheet with parchment paper.

After the dough has risen, punch it down and turn it out onto a lightly floured surface. Divide into 8 equal pieces or make one 12- to 14-inch pizza. Either way, stretch and press on the dough to make it thin; it will be springy and resistant. Transfer the dough to the baking sheet, season with oil, salt and pepper, and the remaining teaspoon of thyme, and bake for 5 minutes. Remove the dough from the oven and spread the onions and cheese on top. Bake 15 to 20 minutes more, or until golden and crisp. Garnish with fresh thyme sprigs and serve.

6

Desserts

Science has found that our love of sweet things is rooted in evolution—our bodies store sugar as valuable energy—but it's also a reflection of more complex cultural factors. The humble infrastructure that produced the first gingerbread—nothing more than a few stale bread crumbs soaked in day-old wine and spices—is a far cry from the Italian royal court that launched the ephemeral and icy innovation that is the fruit sorbet. The coveted confections we call dessert arose from technologies and culinary experiments that have been evolving for hundreds of years. Columbus encountered the cacao bean on his fourth mission to the Americas in 1502, but not until the early nineteenth century did it begin to take on the sweet, creamy form we know and love as chocolate.

As luck would have it, creativity and serendipity are continually wreaking havoc

on the status quo. How else to explain the happy accident that is the Molten Chocolate Cake? One day a classic cake is pulled from the oven just a little too soon and suddenly, with one lusciously runny spoonful, the paradigm shifts. Dessert is a vast universe of possibilities, ranging from rustic and hearty to delicate and sublime, and it never fails to feel like a reward, especially when it's reserved for special occasions. Victory is sweet, and so are the treats we eat to celebrate it.

At BG, the grand finales are no mere afterthought, as illustrated by the tempting recipes in this book. Though some are a bit more labor-intensive—BG's heavenly signature confection takes two days to prepare—few are overwhelmingly complex, and they all deliver that wonderful thrill of pleasure that accompanies every last bite.

THE BG

Makes 15 desserts

Elegant, extravagant, and even gluten-free, BG's signature chocolate-hazelnut dessert is worth the effort required to create its various components. At the restaurant, it is served in a modest portion that still feels indulgent, though edible gold stars and a sugar disk emblazoned with the store's logo take it over the top. Plan to start making this two days before serving, as everything requires overnight chilling.

WHITE CHOCOLATE MOUSSE

1 pound white chocolate, chopped
3 3×5-inch gelatin sheets, or
 2½ teaspoons powdered gelatin
1¾ pints heavy cream
2½ pints heavy cream, whipped

DARK CHOCOLATE MOUSSE

1¼ pounds bittersweet chocolate,
 chopped
5⅓ tablespoons unsalted butter
10 large eggs, separated
¼ cup boiling hot water
½ cup plus 1 tablespoon sugar
10 ounces heavy cream, whipped,
 then chilled

HAZELNUT CAKE

9 ounces milk chocolate, chopped
1½ sticks unsalted butter
4 large egg yolks
4 large eggs
1⅛ cups (packed) light brown sugar
1¼ cups hazelnut flour

TO MAKE THE WHITE CHOCOLATE
MOUSSE: In a double boiler, melt the
white chocolate until smooth. Scrape
it into a large bowl and set aside.
Meanwhile, soften the sheets of
gelatin in a small bowl of cold water.

In a small saucepan over medium
heat, warm the 1¾ pints of heavy
cream. Turn off the heat and cover to
keep warm. Using a stand mixer fitted
with the whisk attachment, a handheld
beater, or a balloon whisk, whip the
cream until soft peaks form. Remove
the gelatin sheets from the water and
gently squeeze out any excess water.

Combine the softened gelatin sheets,
or the powdered gelatin, if using, and
warm cream with the white chocolate.
Fold in the whipped cream. Allow to
set overnight, tightly covered, in the
refrigerator.

TO MAKE THE DARK CHOCOLATE
MOUSSE: In a double boiler, melt
the bittersweet chocolate and butter
together until smooth. Scrape into a
medium bowl and cool. Mix in the egg
yolks and set aside.

In a small bowl, stir the hot water
and sugar together until the sugar is
completely dissolved. Using a stand
mixer fitted with the whisk attach-
ment, a handheld beater, or a balloon
whisk, whip the egg whites until
frothy. Stream in the sugar syrup until
the egg whites form a meringue with
soft, glossy peaks. Fold the bittersweet
chocolate mixture into the meringue,
then fold in the chilled whipped cream.
Allow to set overnight, tightly covered,
in the refrigerator.

(continued on next page)

TO MAKE THE HAZELNUT CAKE:
Preheat the oven to 325°F and place
a rack in the middle. Line a rimmed
baking sheet with parchment paper or
use a Silpat. Set aside.

Melt the milk chocolate and butter in
a double boiler and set aside.

Using a stand mixer fitted with the
whisk attachment, or a handheld beater,
whip together the egg yolks, eggs, and
brown sugar until fluffy. Fold in the
flour and gently stir in the chocolate
and butter mixture.

Spread the batter in a thin layer on a
quarter sheet pan and bake until a tester
comes out clean, 8 to 10 minutes. Remove
from the oven and cool on a rack.

DESSERT ASSEMBLY: Fit 2 pastry bags
with large open tips. Fill 1 bag with
the white chocolate mousse and the
other with the dark chocolate mousse.
Using a lined 2½-inch ring mold, place
a layer of hazelnut cake on the bottom,
then pipe in ⅓ dark chocolate mousse,
followed by ⅓ white chocolate mousse,
and top with another ⅓ dark chocolate
mousse. Repeat with the remaining
ingredients. Refrigerate overnight. To
serve, unmold and plate.

DOUBLE CHOCOLATE TART

Serves 6

The only thing better than chocolate is more chocolate, and a generous sprinkling of flaky salt really helps the flavor sing. Since chocolate and salt are the focal tastes of this dessert, BG uses Valrhona chocolate and Maldon sea salt. Made with these ingredients and a high-quality cocoa powder (Valrhona also makes a good one), this tart is exemplary.

1⅔ cups all-purpose flour
½ cup unsweetened cocoa powder
½ cup sugar
1½ sticks unsalted butter
1 large egg

12 ounces Valrhona bittersweet chocolate (70% cacao), finely chopped
1¼ cups heavy cream
Maldon sea salt

Combine the flour, cocoa, and sugar in the bowl of a stand electric mixer fitted with the paddle attachment and mix briefly. Add the butter and mix on low speed until crumbly.

Add the egg and blend until the dough comes together to form a ball.

On a floured surface, gently knead the dough, making sure all the ingredients are fully incorporated and being careful not to overwork. Form the dough into a disk and wrap in clear plastic wrap. Chill for 30 minutes.

Place a rack in the middle of the oven and preheat to 350°F.

On a lightly floured surface, roll out the pastry to a ⅛-inch-thick round, dusting with flour as necessary to prevent sticking. Transfer the crust to a 9-inch tart pan, pressing into the bottom and up the sides. Trim the dough flush with the edge of the pan and chill, covered with plastic wrap, for 30 minutes.

Once chilled, use a fork to prick the tart shell all over. Carefully line the shell with foil, weight with pie weights or dried beans, and bake until the crust is set, 20 to 25 minutes.

Carefully remove the foil with the pie weights and cool the tart shell in the pan on a wire rack.

While the crust cools, make a ganache by placing the chocolate in a medium heatproof bowl. In a small saucepan, heat the cream until it steams, then pour over the chopped chocolate and stir until smooth.

Fill the tart shell immediately with the ganache, using an offset spatula to smooth the top. Once the ganache has cooled slightly, sprinkle a few pinches of sea salt on top. Refrigerate until set, about 2 hours. Before serving, let the tart sit at room temperature for 30 minutes.

MOLTEN CHOCOLATE CAKE

Serves 4

Although its origins are disputed, legend has it that this supremely rich and chocolaty dessert was the result of a standard chocolate cake recipe being precipitously removed from the oven. Served warm, it reveals a runny center that acts like a sauce for the featherlight cake. Make the batter ahead and bake it at the last minute, first making sure it has come back to room temperature.

5 teaspoons all-purpose flour

1 tablespoon unsweetened cocoa powder

8 tablespoons (1 stick) unsalted butter, plus extra for greasing ramekins

6 ounces best-quality chocolate (70% cacao), chopped

3 large eggs

⅓ cup sugar

⅛ teaspoon salt

Vanilla ice cream, for serving

Place a rack in the middle of the oven and preheat to 425°F.

In a small bowl, combine 1 tablespoon of the flour and the unsweetened cocoa. Butter four 6-ounce ramekins and lightly dust with the flour-cocoa mixture. Place the ramekins on a baking sheet and set aside.

In a double boiler over simmering water, melt the butter with the chocolate and whisk until smooth.

Using a stand mixer fitted with the whisk attachment, a handheld beater, or a balloon whisk, beat the eggs, sugar, and salt at high speed until thick and pale.

Slowly fold the melted chocolate into the egg mixture, followed by the remaining flour. Pour the batter into the prepared ramekins and bake until the sides of the cakes are firm but the centers are still soft, about 12 minutes. Let the cakes rest in the ramekins for 1 minute, then place a plate over each ramekin and carefully turn it over onto the plate. Tap gently on the bottom of the ramekin, then carefully lift it off the plate to release the cake.

Serve immediately, accompanied by a scoop of vanilla ice cream.

WHITE CHOCOLATE
BREAD PUDDING

Serves 6

Bread puddings can be heavy, but this version, a BG favorite, is lighter fare. Brioche, a spongy, egg-enriched bread, forms the base and soaks up a light milky custard infused with white chocolate and fresh ginger. This sophisticated combination is as delicious as it is unexpected. Serving it with vanilla gelato adds a wonderful flavor and texture counterpoint.

8 cups 1-inch brioche cubes, crust included

3 cups whole milk

1 cup sugar

1 cup white chocolate, chopped

½ teaspoon grated peeled fresh ginger

3 large eggs

Vanilla gelato, for serving

Place a rack in the middle of the oven and preheat to 325°F.

Line a baking sheet with parchment paper. Spread the brioche on the baking sheet and toast in the oven for about 15 minutes. Transfer to a large bowl.

In a small saucepan, boil the milk with ½ cup of the sugar, ½ cup of the chocolate, and the ginger.

In a separate bowl, whisk together the eggs and the remaining ½ cup sugar. Add the milk mixture, a few teaspoons at a time, to the eggs, whisking all the while. Continue slowly adding the rest of the milk, whisking constantly. Don't combine too quickly or the eggs will scramble. Once all the milk is incorporated, pass the mixture through a fine sieve over the bowl with the toasted brioche. Allow the brioche to absorb the liquid for 1 hour.

Place a rack in the middle of the oven and preheat to 325°F. Lightly butter six 4-inch ramekins.

Scoop the bread mixture into the ramekins and top with the remaining ½ cup chocolate. Arrange the ramekins in a large roasting pan and place in the oven. Create a *bain-marie*, or water bath, by pouring hot water into the pan to come halfway up the sides of the ramekins. Bake until the top of the pudding is puffy but firm, about 45 minutes. Serve warm, accompanied by vanilla gelato.

BREAD PUDDING WITH PEACHES AND CARAMEL SAUCE

MICHELLE SMITH, FOUNDER AND DESIGNER, MILLY

Serves 6 to 8

After working for several couture houses in Paris, Michelle returned to New York to design her own collection of polished, feminine silhouettes. America connects her to her roots. "My great-great-grandmother loved bread pudding," she says, "and her recipe has been cherished by six generations of my family." Make this cinnamon-scented dessert when ripe, juicy peaches are in season.

2 cups fresh peaches, peeled, pitted, and chopped

1 14-ounce can sweetened condensed milk

3 large eggs, lightly beaten

1¼ cups hot water

4 tablespoons (½ stick) unsalted butter, melted

1 teaspoon ground cinnamon

1 teaspoon vanilla extract

4 cups French bread (crust included), torn into small pieces

Caramel Sauce (recipe follows)

CARAMEL SAUCE

½ cup (packed) light brown sugar

8 tablespoons (1 stick) unsalted butter

2 tablespoons light corn syrup

1 tablespoon dark rum

Place a rack in the middle of the oven and preheat to 325°F. Lightly grease a 9 × 13-inch baking dish with butter or nonstick cooking spray.

Use a large rubber spatula to lightly mash the peaches in a large mixing bowl. In a small bowl, stir together the milk and eggs, then mix into the peaches. Stir in the hot water, butter, cinnamon, and vanilla. Add the bread to the peach mixture and combine until the bread is completely moistened. Turn into the baking dish and bake until a knife inserted into the center comes out clean, about 70 minutes.

About 10 minutes before the pudding is done, make the caramel sauce. Serve the bread pudding warm, with warm caramel sauce drizzled on top. Leftover bread pudding can be stored in the fridge and reheated, but it must be served with fresh caramel sauce.

TO MAKE THE CARAMEL SAUCE: Combine the sugar, butter, corn syrup, and rum in a saucepan. Bring to a boil over medium heat and simmer for 3 to 4 minutes, or until just slightly thickened. Cool slightly.

GRANDMA HILDA'S GOLDEN CRISP CHOCOLATE CHIP COOKIES

ALIZA LICHT, LUXURY FASHION PUBLICIST

Makes about 20 cookies

A top publicist, Aliza is known to her legions of Twitter fans as "DKNY PR Girl." But this fashion insider also knows a thing or two about cookies. "Whenever she made these, my grandma Hilda always let me eat the batter," says Aliza. "That's love." Her grandmother's delicious cookies bake up somewhere between chewy and crisp.

2¼ cups all-purpose flour

1 teaspoon baking soda

2½ sticks unsalted butter, at room temperature

1 cup granulated sugar

1 cup (packed) light brown sugar

⅛ teaspoon salt

2 large eggs

2 teaspoons vanilla extract

2 cups semisweet chocolate chips

Place a baking rack in the middle of the oven and preheat to 375°F.

In a large bowl, mix together the flour and baking soda.

In the bowl of a stand mixer fitted with the paddle attachment, cream the butter, granulated sugar, brown sugar, and salt on medium-low speed until pale and fluffy. Add in eggs, one at a time, and continue beating to combine. Beat in the vanilla.

Reduce the speed to low and gradually add the flour mixture, a small amount at a time, beating to combine after each addition until all the flour is mixed in. Using a rubber spatula, fold in the chocolate chips.

Lightly butter a couple baking sheets and line them with parchment paper, or use a Silpat. Portion out the cookie dough in tablespoon increments, spaced about 2¼ inches apart. Bake for 9 to 10 minutes, one cookie sheet at a time. Remove from the oven, cool for 5 minutes, then transfer to a rack to cool completely.

TOASTED COCONUT MACARONS
WITH SALTED CARAMEL

HANSON CHIN, BERGDORF GOODMAN EMPLOYEE

Makes about 40 cookies

The origins of the macaron are purportedly French, though they have been traced back to the arrival of Florentine Catherine de Médicis, who married Henri II in 1533 and brought along her Italian pastry chef. Making these melt-in-your-mouth, meringue-based confections calls for skill and dedication, but the effort is well worth it. "The feeling of biting into a delicious macaron is ephemeral," says Hanson. "Well, until you bite into the next one." His version is made with coconut, rather than the usual almonds, and it requires a scale and candy thermometer for precise measurements.

200 grams coconut flakes
225 grams confectioners' sugar
1 tablespoon meringue powder
 (available at specialty and baking
 supply stores)
5 large egg whites
5 tablespoons granulated sugar
4 drops of brown food coloring
Salted Caramel Filling (recipe follows)

SALTED CARAMEL FILLING
1 cup heavy cream
5 tablespoons unsalted butter,
 cut into pieces
1 tablespoon sea salt
1½ cups granulated sugar
¼ cup light corn syrup

Place a rack in the middle of the oven and preheat to 325°F.

Line a baking sheet with parchment paper. Spread the coconut flakes evenly on the baking sheet and toast in the oven until golden, 7 to 9 minutes, stirring once or twice to cook evenly. Remove from the oven and cool.

Put the coconut flakes in a food processor and pulse for five or six 5-second intervals, making sure there are no large pieces remaining. Using a rubber spatula, gently mix in the confectioners' sugar and meringue powder. Pulse again for three or four 5-second intervals.

Place the egg whites in the bowl of a stand mixer fitted with the whisk attachment and beat on medium. When soft peaks begin to form, sprinkle in the granulated sugar, 1 tablespoon at a time, until stiff peaks form. With a rubber spatula, and using as few strokes as possible, fold in the coconut mixture and food coloring.

Fit a pastry bag with an Ateco #11 plain tip and scoop in the meringue. With the tip pointing directly perpendicular to the prepared baking sheet, gently squeeze the bag to extrude enough batter to make a round cookie 1½ inches in diameter. Maintain an even pressure on the bag to guarantee consistent results. Allow 1 to 2 inches of space between the cookies, as they will expand. Allow to sit for 20 to 40 minutes before baking to help stabilize the batter.

Preheat the oven to 350°F, leaving the rack in the middle.

Bake the cookies for 15 minutes. Leave on the pan to cool completely before gently pulling them off the paper.

To assemble macarons, use a knife or offset spatula to spread a layer of the caramel filling onto the flat side of 1 cookie. Set another cookie on top of it, and very gently press the cookies together. Continue in this manner until all the cookies are filled.

TO MAKE THE SALTED CARAMEL FILLING: In a medium saucepan, bring the cream, butter, and salt to a boil, then immediately turn off the heat and stir the sauce on the stove.

In a larger saucepan over medium-high heat, bring the sugar, corn syrup, and ¼ cup water to a boil. Cook until the sugar has dissolved and the mixture turns pale amber, 5 to 7 minutes. Slowly pour in the butter-and-cream mixture, and stir with a rubber spatula. Bring to a boil again, clip on a candy thermometer, and cook, without stirring, until the mixture reaches 240°F (the soft-ball stage).

Immediately pour the caramel into a heatproof bowl. Cool to room temperature.

SWEDISH GINGER COOKIES

CATHY HORYN, FASHION JOURNALIST

Makes about 40 cookies

The former fashion critic at the *New York Times*, Cathy is well known for her highly discriminating taste on all matters. The recipe for these thin, crisp cookies, a holiday tradition made by her mother, includes a secret ingredient: bacon fat. "Don't be tempted to buy a fancy brand of bacon," she advises. "It will overload the cookies with a smoky flavor."

¾ cup bacon fat, chilled

2 cups sugar

4 tablespoons dark molasses

1 large egg

2 cups all-purpose flour

¾ teaspoon salt

2 teaspoons baking soda

1 teaspoon ground ginger

1 teaspoon ground cloves

1 teaspoon ground cinnamon

Mix until smooth the bacon fat, 1 cup of the sugar, molasses, egg, flour, salt, baking soda, ginger, cloves, and cinnamon in a food processor fitted with a metal blade. Chill the dough for at least 2 hours.

Place a rack in the middle of the oven and preheat to 350°F.

Place the remaining 1 cup sugar into a small bowl. Roll the dough into 1-inch balls, then coat with sugar. Place 2 inches apart on an ungreased cookie sheet and flatten with your fingers. Bake until dark brown, 10 to 12 minutes.

BUTTERSCOTCH BROWNIES

MALLORY ANDREWS, SENIOR VICE PRESIDENT,
MARKETING, BERGDORF GOODMAN

Makes about 25 brownies

When she's not busy polishing the illustrious image of Bergdorf Goodman—including overseeing all the advertising, events, and social media—Mallory can be found baking a batch of these buttery treats, a childhood favorite, which she insists are quite different from blondies. "When my mother's well-worn 1943 copy of *Joy of Cooking* was passed down to me, this recipe brought back great memories," she says. "Be advised, these will immediately disappear from your kitchen!"

8 tablespoons (1 stick) unsalted butter
2 cups (packed) light brown sugar
2 large eggs, lightly beaten
2 teaspoons vanilla extract
1 cup bread flour
2 teaspoons baking powder
1 teaspoon salt

Place a rack in the middle of the oven and preheat to 350°F.

In a medium saucepan over medium heat, melt the butter. Stir in the sugar until fully incorporated, then transfer the mixture to a medium bowl and cool slightly. Beat in the eggs and add the vanilla.

Sift the flour into a separate bowl, add the baking powder and salt, and resift. Stir into the butter mixture.

Line an 11 × 7 × 2-inch glass pan with waxed parchment paper. Scrape the batter into the pan and bake for 30 minutes. Cool, then cut into small squares.

SEASONAL PARFAITS

The presentation of a parfait in a tall, clear dish instantly telegraphs that something special is arriving. At BG, these layered desserts change to reflect the month, the holiday, or whatever is in season. The recipes included here are given as inspiration, since the possibilities are limitless and include everything from custard, yogurt, and ice cream to poached fruit, granola, and nut brittle. What's important is to create a complementary mix of textures and flavors, so that every bite brings a thrill of pleasure.

SOUR CHERRY AND PEACH SHORTCAKE PARFAIT
Layer cubes of shortcake with sautéed sour cherries and peaches. Top with vanilla ice cream.

S'MORES PARFAIT
Layer dark chocolate mousse, graham cracker crumbs, and whipped cream. Top with mini-marshmallows and brown with a brûlée torch.

RED VELVET PARFAIT
Layer cubes of red velvet cake with vanilla pudding. Top with whipped cream.

BANANAS FOSTER PARFAIT
Layer cubes of pound cake and caramelized bananas laced with rum. Top with vanilla ice cream.

BLACK FOREST PARFAIT
Layer cubes of devil's food cake or brownies with stewed cherries. Top with whipped cream.

PETITE CHEESE TARTS

BETTY HALBREICH, PERSONAL SHOPPER, BERGDORF GOODMAN

Makes 40 tarts

Known for her spot-on advice, star-studded clientele, and long tenure at the store, Betty is a true fashion legend. She remembers when these little cheesecakes were all the rage in the 1970s, and they're every bit as delicious today. "Everyone was serving them with afternoon coffee or at dinner parties," she says. "So simple to make, yet anyone who baked back then was a real heroine." Some things never change.

1 cup graham cracker crumbs
4 tablespoons (½ stick) unsalted butter, melted
1 pound cream cheese (not whipped), at room temperature
½ cup sugar
2 large eggs, at room temperature
1 teaspoon vanilla extract
⅛ teaspoon ground nutmeg
⅛ teaspoon ground cinnamon
1 tablespoon lemon zest
Fruit jam, fresh berries, or grated chocolate

Place a rack in the middle of the oven and preheat to 375°F. Line each of 40 mini-muffin tins with a small paper liner.

In a small bowl, mix together the graham cracker crumbs and butter. Place a small spoonful in each paper liner and press to make a compact crust.

In the bowl of a stand mixer fitted with the paddle attachment, beat together the cream cheese, sugar, eggs, vanilla, nutmeg, cinnamon, and lemon zest. Spoon into the prepared crusts, filling the cups to ⅛ inch from the top. Bake for 10 minutes.

Remove from the oven and cool. Top each tart with a teaspoon of jam, a few fresh berries, or a sprinkling of grated chocolate. These may be stored in the refrigerator, tightly covered, for 1 to 2 days. Serve at room temperature or chilled.

FRENCH APPLE TART

CATHERINE MALANDRINO, DESIGNER

Serves 8

Blending the elegance of Paris, the romance of Provence, and the energy of Manhattan, Catherine's designs evoke a powerful femininity. This French expatriate does what she can to stay connected to her roots, including baking this traditional holiday dessert from Normandy. "This dessert reminds me of precious moments gathering with friends and family," she says. "And it makes a delicate and stylish centerpiece." Serve this tart the day it's made.

2 cups all-purpose flour

½ teaspoon kosher salt

1 tablespoon sugar

1½ sticks cold unsalted butter, cut into cubes

½ cup ice water

4 Granny Smith apples

¼ cup sugar

4 tablespoons (½ stick) cold unsalted butter, cut into small cubes

½ cup apricot jelly or warm, sieved apricot jam

2 tablespoons Calvados, rum, or water

To make the pastry, place the flour, salt, and sugar in the bowl of a food processor fitted with the steel blade. Pulse for a few seconds to combine.

Add the 1½ sticks butter and pulse several times to make pea-sized bits. With the motor running, pour the ice water down the feed tube and pulse just until the dough starts to come together. Be careful not to overmix.

Place the mixture onto a floured board and knead quickly into a ball. Flatten the dough into a rectangle, wrap in plastic, and refrigerate for at least 1 hour.

Place a rack in the middle of the oven and preheat to 400°F. Line a baking sheet pan with parchment paper.

Roll out the dough on a floured surface or between sheets of wax paper until it is slightly larger than 10 × 14 inches. Use a ruler to be precise about the size and trim the edges with a small knife. Place the dough on the baking sheet and refrigerate while you prepare the apples.

Peel the apples and cut them in half through the stem. Remove the stems and cores. Slice the apples crosswise in ¼-inch-thick slices.

Place overlapping slices of apples diagonally across the dough, starting at the upper left corner and ending at the lower right corner, and continue to make diagonal rows on both sides of the first one until the entire expanse is covered with apple slices. (For a more pristine arrangement, do not use the apple ends.) Sprinkle with the sugar and dot with the remaining small cubes of butter.

Bake until the pastry is browned and the edges of the apples start to caramelize, 45 to 60 minutes, rotating the pan once during cooking. If the pastry puffs up in one area, cut a little slit with a knife to let the air out. Don't worry! The apple juices will burn in the pan, but the tart will be fine.

When the tart is done, cool on a rack. Gently loosen the crust with a metal spatula so it doesn't stick to the paper. Heat the apricot jelly with the Calvados, and brush the tart all over with this mixture. Serve warm or at room temperature.

PAVLOVA

REBECCA TAYLOR, DESIGNER

Serves 6

Soft, whimsical silhouettes with sophisticated detailing are Rebecca's signature. Though she now lives in New York, her New Zealand roots run deep, so it's no surprise she shared this classic Kiwi dessert named in honor of ballet dancer Anna Pavlova during her tour of New Zealand in the 1920s. "Pavlova was a special treat for our family during the holidays," says Rebecca. "Mum would leave it out to cool and we kids would always sneak a bite." Proof positive that this elegant dessert appeals to the whole family.

4 large egg whites, at room
 temperature
Pinch of salt
1 cup superfine sugar
3 ¼ teaspoons cornstarch

1 teaspoon white vinegar or fresh
 lemon juice
1 ½ teaspoons vanilla extract
Fresh fruit
Whipped cream (page 193)

Place a rack in the middle of the oven and preheat to 300°F.

On a sheet of parchment paper, trace a 9-inch circle. Turn the paper over and place it on a baking sheet.

In the bowl of an electric mixer fitted with the whisk attachment, combine the egg whites with a pinch of salt and beat at medium speed until they hold soft peaks.

With the machine running, add the sugar slowly, 1 tablespoon at a time. After all the sugar has been added, continue beating on high until stiff peaks form. If the meringue feels gritty when rubbed between two fingers, continue beating until all the sugar has dissolved.

Remove the bowl from the mixer and sift the cornstarch over the whites. Add the vinegar and vanilla and gently fold everything in with a rubber spatula.

Line a baking sheet with parchment paper and spoon the mixture onto it. With the tracing as a guide, use an offset spatula dipped in warm water to shape a circle. Form the edges of the Pavlova higher than the center to create a well that can later hold the whipped cream and fruit.

Bake just until small cracks appear but the meringue is still quite pale, about 45 minutes. Turn the oven off, propping the door slightly ajar, and allow the Pavlova to cool completely. Just before serving, mound fresh fruit in the center and dollop whipped cream on top. Slice into wedges.

MY LITTLE VIOLET DARLINGS
(MERINGUE–FILLED PUFFS)

ZAC POSEN, DESIGNER

Makes about 30 pieces

With a vision of American glamour that marries couture technique with a downtown sensibility, Zac designs sartorial confections for the modern young woman. Here he offers a recipe for what he calls "quite the delicious flight of fancy": classic French cream puffs filled with a flavored, cream-enriched meringue colored like delicate flowers.

FOR THE PÂTE À CHOUX

8 tablespoons (1 stick) unsalted butter
¼ teaspoon salt
½ teaspoon granulated brown sugar
1 cup all-purpose flour
5 large eggs

FOR THE FILLING

2 large egg whites
Pinch of cream of tartar
½ cup granulated sugar
2 cups heavy cream
1 teaspoon vanilla extract
2–3 drops violet flavoring essence, or
 1–2 teaspoons orange blossom water
Blue and red food coloring
Candied violets or other candied
 flowers
Lavender or rose ice cream

Place a rack in the middle of the oven and preheat to 375°F. Line a baking sheet with parchment paper and set aside.

TO MAKE THE PÂTE À CHOUX: Place a large saucepan over medium-high heat. Combine the butter, 1 cup water, salt, and brown sugar and bring to a boil. Remove from the heat and add the flour, mixing vigorously for about 5 minutes to cool the dough. Transfer to an electric mixer fitted with the paddle attachment. Mix until the dough forms a ball that doesn't stick to the sides. Add the eggs one at a time, beating until they are incorporated and the mixture is smooth.

Spoon the batter into a large pastry bag fitted with a ½-inch tip and pipe onto the baking sheet in 2-inch swirls. Use a wet spoon to smooth any fine tips sticking out. Bake for 40 minutes, until lightly golden and puffed. Cool completely.

TO MAKE THE FILLING: Combine the egg whites and cream of tartar in a stand mixer fitted with the whisk attachment. Beat until the whites form soft peaks, then slowly add the sugar, 1 tablespoon at a time, beating all the while, until stiff peaks form. If the meringue feels gritty when rubbed between two fingers, continue beating until all the sugar has dissolved. Scrape the meringue into another bowl and set aside while you whip the cream.

Use the stand mixer with a clean whisk attachment to whip together the cream, vanilla, violet essence or orange blossom water, 2 drops of blue food coloring, and 1 drop of red food coloring. When the cream holds soft peaks, turn off the mixer and use a rubber spatula to fold in the egg whites.

TO ASSEMBLE THE PUFFS: Slice the puffs in half crosswise and pipe or spoon in the filling. Serve garnished with candied violets and accompanied by lavender or rose ice cream.

BROWN BUTTER ALMOND CAKE

Serves 8 to 10

Brown butter's warm, nutty notes enhance the flavor of toasted almonds in this comforting cake. Enriched with sour cream and spiked with rum, it's perfect on its own or as the impressive backdrop to roasted pineapple or fresh blackberries. Wrap any leftovers tightly in aluminum foil and store at room temperature for 1 to 2 days.

1 cup cake flour

2 teaspoons baking soda

½ teaspoon cinnamon

½ teaspoon salt

1 cup whole almonds

1 stick plus 2 tablespoons unsalted butter, plus more for buttering the pan

2 tablespoons dark rum

1 tablespoon vanilla extract

¼ cup sour cream

1½ cups granulated sugar

9 large egg whites, at room temperature

¼ cup sliced almonds

Confectioners' sugar for dusting (optional)

In a medium bowl, sift together the flour, baking soda, cinnamon, and salt. Set aside.

Place a rack in the middle of the oven and preheat to 350°F. Butter a 10-inch springform pan. Line the bottom with a round of parchment paper.

Spread the whole almonds on a baking sheet and bake until lightly toasted and aromatic, 5 to 10 minutes, stirring halfway through to ensure even coloring.

In a small saucepan over medium heat, melt the butter and continue to cook for 5 to 7 minutes. Watch carefully, and when brown flecks appear in the bottom of the pan, immediately scrape all the butter into a medium bowl. Set aside to cool. When cool, stir in the rum, vanilla, and sour cream.

In a food processor, pulse the almonds and ¾ cup of the sugar until finely ground. Pour the mixture into a medium bowl and stir in the sifted dry ingredients.

In a stand mixer fitted with the whisk attachment, or using a handheld beater, beat the egg whites on low until they start to foam. Increase the speed to medium-high and beat until the whites start to hold peaks. Beat in the remaining ¾ cup sugar in a very slow, steady stream, continuing to beat until the whites hold soft peaks.

Scoop a large dollop of the egg whites into the butter mixture and gently stir it in. Fold half the almond mixture into the remaining egg whites and then half the butter mixture into the egg whites. Repeat, ending with the butter mixture.

Pour the batter into the pan. Smoothe the top with a rubber spatula and give the pan a quick spin to even out the batter. Sprinkle the sliced almonds over the top. Bake in the middle rack of the oven until golden, 45 to 50 minutes. The center should spring back when pressed lightly; the sides of the cake will pull away from the edges of the pan. When cool, carefully remove from the pan. Dust with confectioners' sugar before serving.

CARROT CAKE

Serves 10

This simple, moist layer cake has a pleasantly vegetal sweetness from the carrots, and the walnuts give it just the right texture. The cream cheese frosting—a lush, vanilla-scented dream—makes it truly spectacular, particularly as there's an additional ribbon of it running through the center of the cake. Enjoy this dessert with a cup of afternoon tea or after a light meal.

2 cups cake flour
2 teaspoons baking soda
2 teaspoons cinnamon
1 teaspoon salt
2 cups sugar
1 cup vegetable oil
4 large eggs, at room temperature
1 tablespoon vanilla extract
¾ cup chopped walnuts
2½ cups finely grated carrots
Cream Cheese Frosting
 (recipe follows)

CREAM CHEESE FROSTING
10 ounces cream cheese, softened
4¾ cups confectioners' sugar
1 teaspoon vanilla extract

Place a rack in the middle of the oven and preheat to 325°F. Butter and flour three 9-inch cake pans.

Sift together the cake flour, baking soda, cinnamon, and salt.

Using a stand mixer fitted with the paddle attachment, beat the sugar, oil, eggs, and vanilla on low speed. Fold in the dry ingredients and mix well. Using a rubber spatula, stir in ½ cup of the nuts and the carrots. Pour the batter evenly into the prepared pans.

Bake until a knife inserted into the center comes out clean, 45 to 50 minutes. Cool completely.

Spread the frosting between each layer and over the top. Garnish with the remaining ¼ cup chopped nuts.

TO MAKE THE CREAM CHEESE FROSTING: Place the cream cheese, sugar, and vanilla in a stand mixer fitted with the whisk attachment and mix until thoroughly combined and fluffy.

PEAR AND SPICE CAKE

Serves 8 to 10

Lighter than gingerbread but similar in flavor, this cake is featured on the fall BG menu. The cake showcases the flavor of ripe pears against the bite of fresh ginger and the dark sweetness of molasses. It's wonderful served with a scoop of lemon curd, a dollop of whipped cream, or a chopped relish of fresh pear and crystallized ginger.

2½ cups flour
¼ teaspoon ground cloves
½ teaspoon ground cinnamon
½ teaspoon salt
1 teaspoon baking soda
2 pears, peeled, halved, and cored
2 tablespoons grated, peeled fresh ginger
1 cup milk
4 tablespoons unsalted butter, plus more for greasing
¼ cup (packed) light brown sugar
1 large egg
⅓ cup molasses

Place a rack in the middle of the oven and preheat to 375°F. Butter a 9-inch round cake pan with butter and line it with parchment paper.

Into a medium mixing bowl, sift together the flour, cloves, cinnamon, salt, and baking soda and set aside.

Coarsely grate the pears, mix with the ginger, and set aside.

Gently warm the milk over low heat and set aside.

Using a stand mixer with the paddle attachment, or a handheld beater, cream the butter and sugar together. When fluffy, add the egg and continue beating. Stir in the molasses until smooth. Then, alternating, a little bit at a time—and beginning and ending with the dry ingredients—beat the dry ingredients, milk, and ginger/pear mixture into the batter. Pour the mixture into the prepared pan and bake until a knife inserted into the center comes out clean, about 40 minutes. Cool before serving.

FIG AND BALSAMIC SWIRL ICE CREAM

KRISTINA ERFE, BLOGGER AND DIGITAL MEDIA CONSULTANT

Makes 2½ pints

With its inspired combination of soft figs and sweet vinegar swirled through rich ice cream, Kristina's recipe won the Bergdorf Goodman blog's contest for best recipe. The reward was inclusion in this book. Of the fig, she says, "At its peak ripeness, this luscious fruit has a honeyed sweetness that I like to pair with a balsamic syrup for a very seductive dessert."

1 pound fresh figs, tops trimmed
and halved
¼ cup plus ⅔ cup sugar
1½ tablespoons fresh lemon juice
2 cups whole milk

1 cup heavy cream
4 large egg yolks
1 cup best-quality balsamic vinegar
Boiling water, as needed

In a medium saucepan over medium-low heat, combine the halved figs with ¼ cup of the sugar and the lemon juice. Stir until the juices thicken, about 10 minutes, and remove from the heat. Cool for at least 2 hours, or store overnight, covered, at room temperature.

Purée three-quarters of the fig mixture. If there are any pieces larger than ½ inch in the remaining quarter of the mixture, roughly chop them into smaller bits.

In a medium saucepan over medium-low heat, combine the milk and heavy cream, and heat to 170°F on an instant-read thermometer, stirring constantly so a skin doesn't form on top.

Place the egg yolks in a large bowl and gradually whisk in the remaining ⅔ cup sugar until thick and pale yellow. Slowly whisk the milk-cream mixture into the egg yolks until thoroughly incorporated.

Place this custard mixture back in the saucepan over medium-low heat, stirring constantly until it reaches 180°F. Remove from the heat and strain into a medium bowl. Place this bowl in a larger bowl filled with ice cubes and cold water. Stirring constantly will help the mixture cool faster. Alternatively, refrigerate the custard until cold.

Once cold, whisk in the fig purée. Pour the full mixture into an ice cream maker and process according to the manufacturer's instructions. About 10 minutes before the ice cream is finished, add the remaining fig mixture.

While the ice cream maker is working, pour the balsamic vinegar into a small saucepan and simmer over medium-low heat, until thick, syrupy, and reduced to no less than ¼ cup. As the vinegar starts to become thicker, stir constantly with a wooden spoon and watch carefully to avoid burning. When reduced, take off the heat immediately but continue stirring, since it continues to thicken as it cools. Pour in some boiling water to help thin the syrup if it thickens too much. Pour the vinegar into a squeeze bottle and either use immediately or refrigerate until needed. Bring back to room temperature before using.

Once the ice cream is finished, pour it into a freezer-proof container and drizzle the balsamic syrup on top. Using a butter knife, swirl the syrup through the ice cream by making tight zigzagging cuts throughout the mixture. Press a sheet of parchment paper over the top, seal tightly, and freeze for 4 hours before serving.

STICKY TOFFEE PUDDING

Serves 6

This luscious dessert is a much-requested staple of BG's holiday menu. A thick caramel sauce is poured into the just-baked pudding, infusing it with a toasty sweetness. The cool contrast of whipped cream or vanilla gelato makes a sublime accompaniment.

1½ cups chopped pitted dates
1 cup hot water
1¼ cups all-purpose flour
1 teaspoon baking powder
¼ teaspoon baking soda
½ teaspoon salt
4 tablespoons (½ stick) unsalted butter,
 at room temperature
½ cup (packed) light brown sugar

2 large eggs
1 teaspoon vanilla extract
Toffee Sauce (recipe follows)

TOFFEE SAUCE
2½ cups heavy cream
1 cup (packed) dark brown sugar
½ cup (packed) light brown sugar
8 tablespoons (1 stick) unsalted butter

Place a rack in the middle of the oven and preheat to 350°F.

Butter and flour six 3-inch ramekins. Place the dates in a small bowl with the hot water for 20 minutes to soften, then drain well.

In a small bowl, combine the flour, baking powder, baking soda, and salt. Set aside.

In an electric mixer fitted with the paddle attachment, cream the butter and sugar. Add the eggs one at a time, beating well after each addition. Mix in the vanilla, then the dates, and then the flour mixture. Spoon the batter into the ramekins and bake until a toothpick inserted into the center comes out clean, 30 to 35 minutes. Cool on a rack.

Using a chopstick or skewer, poke about 6 holes in each cake and pour half of the toffee sauce over the puddings. Ladle the remaining sauce on serving plates and place the puddings on top. Serve with a dollop of whipped cream or a scoop of vanilla gelato, if desired.

TO MAKE THE TOFFEE SAUCE:
In a medium saucepan, bring all the ingredients to a boil, stirring constantly until the sugars dissolve and the sauce thickens, 5 to 10 minutes.

EGGNOG PIE

NINA GARCIA, CREATIVE DIRECTOR, *MARIE CLAIRE* MAGAZINE

Serves 8 to 10

This hundred-year-old German recipe comes from Nina's mother-in-law, Ann Conrod. "Her eggnog pie makes for the perfect ending to any holiday feast," says Nina. "It's light and smooth, and the brandy gives it just the right amount of punch to get you out of a food coma." You can find a good-quality prebaked pie shell in the freezer section of most gourmet food stores.

4 large eggs, separated

¾ cup sugar

½ teaspoon salt

1 cup whole milk

2½ teaspoons unflavored powdered gelatin

3 tablespoons brandy or rum

1 9-inch pie shell, prebaked

1 cup heavy cream

2 tablespoons confectioners' or granulated sugar

1 teaspoon vanilla

Ground nutmeg

In a medium bowl, lightly beat the egg yolks. Add ½ cup of the sugar, the salt, and milk. In a double boiler over medium heat, cook the mixture, stirring frequently, until a custard forms and coats the spoon.

Meanwhile, sprinkle the gelatin over ¼ cup cold water in a cup or a small bowl (be careful not to dump all the granules in a pile, as they won't dissolve). Let stand for 5 to 10 minutes. Heat gently by placing the cup into a larger bowl filled with very hot water and stir until the gelatin is dissolved.

Remove the custard from the heat and stir in the gelatin. Cool in the refrigerator until it begins to congeal around the edges, about 30 minutes. Remove from the refrigerator, add the brandy, and stir to combine.

Beat the egg whites with the remaining ¼ cup sugar until stiff peaks form. Fold into the custard and scrape the mixture into the pie shell. Refrigerate until firm.

Whip the heavy cream, adding sugar and vanilla. To serve, top the pie with the whipped cream and sprinkle with nutmeg.

NUTTY GRANOLA

JOSEPH ALTUZARRA, DESIGNER

Serves 8

His designs for women are the ultimate in sexy sophistication, but this recipe for granola shows off Joseph's domestic side. Crunchy, filled with healthy ingredients, and just sweet enough, the granola is the result of a collaboration with his mother, Karen. "Both of us have been tinkering away at it for years," he says. "I hope that you will tweak it to your liking!" Just remember that any dried fruit needs to be stirred in after the granola comes out of the oven.

4 cups old-fashioned oats

4 large handfuls of mixed chopped nuts, such as any combination of pecans, walnuts, pistachios, and almonds

1 tablespoon ground cinnamon

½ cup safflower or other neutral oil

Scant ½ cup honey, pure maple syrup, or agave nectar

Sesame, pumpkin, or sunflower seeds (optional)

Ground ginger (optional)

Sea salt (optional)

Dried cranberries or raisins (optional)

Place a rack in the middle of the oven and preheat to 350°F.

Butter a rimmed baking sheet and line it with parchment paper, or use a Silpat, so the granola won't stick.

In a large bowl, mix together the oats, nuts, and cinnamon. Stir in the oil and honey. If desired, add the seeds, ginger, and salt.

When the mixture is well blended, spread it evenly on the baking sheet and press it down flat with the back of a metal spatula.

Bake for about 30 minutes, keeping a close eye on it and rotating the pan every 10 minutes. The granola is done when it's deeply golden and fragrant.

Remove from the oven and stir in the dried fruit if desired. Cool in the pan, where it will become crisp, like a giant granola bar. Break the bar into pieces and store in a tightly sealed container.

Acknowledgments

Bergdorf Goodman would like to express our deepest gratitude to the people without whom *The Bergdorf Goodman Cookbook* could never have existed.

To Mallory Andrews, senior vice president of marketing, who conceived of the idea for the book and was a driving force in making it a reality.

To BG Restaurant director Michael Perricone, for providing insight into the restaurant's most famous and beloved dishes, and to former executive chef Marybeth Boller, for sharing her recipes for them.

To Laura Silverman, whose eloquence transformed a collection of recipes into a full-fledged cookbook with a flavor all its own, and to Lisa Nicklin and Mary Dodd, who had the enviable job of taste-testing every delicious dish.

To Konstantin Kakanias, for bringing these recipes and the BG experience to life with his wonderful illustrations.

To Hal Rubenstein, for sharing his wit and wisdom.

To Elizabeth Viscott Sullivan, executive editor, and Lynne Yeamans, art director at Harper Design; book designer Tanya Ross-Hughes; and Lisanne Gagnon, art director at Bergdorf Goodman, who made sure all the ingredients of the book came together just right.

To Barbara Ragghianti, for keeping the project on track from start to finish.

To every one of our guest contributors, for tapping friends, family, and their very own culinary expertise to bring us a diverse collection of winning recipes.

Thank you—and bon appétit!

Index of Recipes and Contributors

About the Director of BG Restaurant

MICHAEL PERRICONE joined Bergdorf Goodman as director of restaurants in 2007. Prior to coming to Bergdorf Goodman, Michael was the general manager of the restaurants at Neiman Marcus San Francisco as well as the regional manager for the West Coast and Hawaii restaurants for the company. He lives in New York City.

About the Writers and Illustrator

LAURA SILVERMAN is a writer and editor who advocates "truly shameless indulgence" on her blog, *Glutton for Life*. A former copy director at Bergdorf Goodman, a passionate cook, and an intrepid gourmand, she is in her element at the intersection of fashion and food. Now residing upstate, Laura is a frequent contributor to *Edible Hudson Valley* and *Gather*, and she has a weekly segment about cooking on her local NPR station. She lives in Sullivan County, New York.

HAL RUBENSTEIN is a writer, a designer, and one of the founding editors of *InStyle* magazine, where he served as fashion director for fifteen years. Rubenstein works privately with brands such as Giorgio Armani, Donna Karan, Gabriel & Co., and American Express. The author of the best-selling *100 Unforgettable Dresses* (Harper Design), he has written cover stories and interviews and served as a columnist on various pop culture topics for *The New Yorker*, *New York* magazine, *Interview*, *Elle*, *Vogue*, *Vanity Fair*, and *Details*. He is a frequent red carpet commentator for programs such as *The Today Show*, *Extra*, and *Access Hollywood*. He lives in New York City.

KONSTANTIN KAKANIAS's drawings, paintings, sculptures, and animated films have been exhibited worldwide. His drawings have been published in numerous magazines internationally, including *The New Yorker*, *Interview*, *Vogue*, and the *New York Times*, where he is currently a contributing editor for *T* magazine. He has also published several books of his work and designed textiles for both fashion and home decoration. A passionate ceramicist and a chef at heart, Kakanias lives in Los Angeles with his husband, Joe, and their ultrachic Boston terrier, Renzo.

THE BERGDORF GOODMAN COOKBOOK

HarperCollins books may be purchased for educational, business,
or sales promotional use. For information please e-mail the
Special Markets Department at SPsales@harpercollins.com.

First published in 2015 by
Harper Design
An Imprint of HarperCollins*Publishers*
195 Broadway
New York, NY 10007
Tel: (212) 207-7000
Fax: (855) 746-6023
harperdesign@harpercollins.com
www.hc.com

Distributed throughout the world by
HarperCollins*Publishers*
195 Broadway
New York, NY 10007

ISBN 978-0-06-231855-8

Library of Congress Control Number: 2013946870

Book design by Tanya Ross-Hughes

Printed in China
First Printing, 2015